SILVIA BOTTI / MASSIMO CAIAZZO

LIVING COLOURS

DISCOVERING THEIR LANGUAGE TO UNDERSTAND AND USE THEM IN DECORATING YOUR HOME

HOAKI

Hoaki Books, S.L.
C/ Ausiàs March, 128
08013 Barcelona, Spain
T. 0034 935 952 283
F. 0034 932 654 883
info@hoakibooks.com
www.hoaki.com
☺ hoakibooks

Living Colours.
Discovering their Language to Understand and Use them in
Decorating your Home.

ISBN: 978-84-19220-37-0

Copyright © 2023 Hoaki Books, S.L.
Copyright © 2021 Antonio Vallardi Editore, Milán
Original title: *Abitare i colori*

Authors: Silvia Botti y Massimo Caiazzo
Translation: Mariotti Translations
Graphic Design: Giovanna Ferraris / theWorldofDot
Layout: Michele d'Agostino
Text editing: Antonella Palumbo, N.d.R. – Turín

D.L.: B 8857-2023
Printed in China

Contents

INTRODUCTION

A MATTER OF INSTINCT AND EXPERIENCE

From the beginning of the eighties colours seemed to disappear from our homes, from architecture and design. For at least three decades we plunged ourselves into the safe and comforting world of neutral and pastel shades. Today's interiors, however, are pervaded by bright and expressive tones, by a powerful use of colour on surfaces, as well as in furnishings and accessories. The almost entirely achromatic minimalism has been succeeded by a dizzying rise of colour driven by the desire for change, by the yearning for self-expression, by the need to create an ideal environment for oneself and one's loved ones. And this was fed above all by the explosion of decorative opportunities that arose in many different fields from new technologies and innovative applications.

But why does colour capture our attention and fascinate us to the point of seduction? The answer is easy: because it is mysterious. To speak of colour means first of all acknowledging its enigmatic nature, the inexplicable process of sublimation that through the centuries has made it ritual, memory, symbol, and emotion. The very word "colour" has arcane roots. Its etymology is linked to the Sanskrit root *kal*, from which comes the Sanskrit *kalanka*/stain and *kala*/black, dark. It is the root that we also find in the Latin *celare*, that is, to hide or conceal. Colour is, therefore, wonder, transformation, but also illusion, because scientifically proving its existence is impossible.

That is why colour is not a discipline. It is a fascinating topic that involves every field of knowledge and can be approached from

every angle. To us it speaks of poetry and emotion, but colour is first and foremost an extraordinary strategy of nature, a formidable means of information closely linked to the survival of living beings. Through colour, Mother Nature conveys (or conceals) crucial information. It can highlight the beauty and power of a male specimen in the mating season or a flower during pollination, just as it can conceal prey from its predators by camouflaging it among lush foliage or on the seabed.

For human beings it is no different. For us too, colour plays an essential role in survival, as it conveys most of the information we receive from our environment. For us, the colours of nature are the first indicator of the quality of food resources of both animal and plant origin. Since the time of mankind's great migrations, when humans were still hunters and gatherers, colours have been essential for identifying the territories richest in prey and edible plants. And in the course of evolution, it is always through colours that mankind has learnt to identify the most fertile lands to cultivate. In short, colours tell us if a food is spoilt, if a mushroom is poisonous, if a fruit is unripe, but they also suggest the vitamin content of fruit and vegetables, the protein content of meat, even though we may not be able to assess this rationally. The reason is simple and relates precisely to our nature as bipedal individuals. Ever since our ancestors assumed the upright position, our visual field has become wider, but at the same time the effectiveness of our olfactory receptors, compared to those of other mammals, has been limited by their greater distance from the ground. Sight has become our main sense, and colour vision, in particular, allows us to initiate a kind of "intuitive signalling" that interacts with other signals, such as olfactory and acoustic ones, to give us a global perception. The interaction between the senses, as we will see in detail in the first chapter of this book, is crucial to perception because our

brain constantly processes all the information transmitted by our external receptors. And so colour is also able to influence our perception of temperature, volume, weight, the passage of time, and noise. When faced with colour, all information flows into a unified perception where experience and instinct merge. Thus, for example, red provokes an instinctive reaction in us and from an emotional point of view represents an alarm. Yellow gives rise to a mainly emotional reaction that triggers attention, a state of alert. Green corresponds to both an emotional and rational reaction, because it conveys the impression of security. Blue, on the other hand, causes a mainly rational reaction, makes us aware, leads us to evaluate and decide.

In short, our reactions to colour are complex and influenced by many factors. Frank H. Mahnke — a refined colour designer and theorist, one of the world's leading experts on the subject — summarised the human experience of colour in 1996 in an effective image that has become an indispensable reference in the field, a pyramid similar to that of the Mediterranean diet. At the base are biological reactions to the colour stimulus, and rising up we find the collective unconscious, associations of ideas, cultural influences, then taste with fashions and styles, culminating at the apex with the personal relationship we establish with a colour. Our reaction to colour is therefore total; we are influenced by it both physiologically and psychologically. Colours stimulate emotions, unconscious reactions, take on personal and collective meanings. A colourful environment — or to put it in technical language, a chromatic context — can both positively and negatively affect our general psychophysical well-being, while at the same time arousing unconscious reactions and emotions. This is why colour is a determining factor in enhancing places (and products) in their social, cultural, and even commercial aspects. In short, colouring

the environments where we live is a great gesture of awareness and freedom. It is an act of love towards ourselves and the people we care about. It is a decisive step towards a better quality of life.

But how do you learn to speak the language of colour? How do you move with ease and confidence in a maze of endless possibilities? How do you create a colourful, harmonious and beautiful home? This book tries to explain it. It does so by recounting the wonderful world of colours, its origins, secrets and curiosities, and providing some technical tools, introducing simple rules, and offering practical advice and creative ideas. These can be put into practice in an exclusive and personal project, or maybe just treasured, with the aim of ultimately understanding why in some environments we are just fine and in others we feel uncomfortable.

Colour is able to influence our perception of the temperature and noise level of an environment, the volume and weight of an object, and even the passage of time. This happens because colour conveys a large part of the information we receive from the environment in which we find ourselves. Our sight is our most developed sense, but it interacts with all the other sensory stimuli — acoustic, olfactory, tactile, gustatory — transmitting essential information to the brain and ensuring a global perception. We are not aware of it, but this natural mechanism is crucial, because it is what stimulates our reaction, whether positive or negative, in every situation. And it is decisive in the formulation of our judgement.

Chapter 1

A WORLD OF SENSATIONS

THE REACTION OF OUR BRAIN AND BODY AT THE SIGHT OF COLOURS

We often use expressions such as "a sweet scent", "a noisy colour", "a cold voice". To explain sensations, emotions and feelings we often resort to a particular metaphor known as synaesthesia. This is a rhetorical device that associates in a single image two words belonging to two different sensory spheres. So a perfume we perceive through our sense of smell we associate with the idea of a sweet taste, a colour we see with that of a noise that disturbs our hearing, a voice we hear with the tactile sensation of intense cold. The term is derived from the Greek: *da sýn*, meaning with/together, and *da aisthánomai*, I perceive/understand. This language technique was already known in ancient times, as far back as Pythagoras and Aristotle, and it has generated some of the most famous poetic verses in the history of literature. One for all, Petrarch's "Chiare fresche et dolci acque" [Clear water, fresh and sweet].

But you don't have to be a poet to practise synaesthesia. Actually, it is very natural for us to associate smell with taste, sight with hearing, or perhaps hearing with touch, because our five sensory apparatuses are not completely independent. Specific studies in neurophysiology have shown that when a stimulus reaches our brain, several sensory areas are activated simultaneously. Certainly these are mild reactions, not comparable to what neuroscience identifies as true synaesthesia, the phenomenon whereby two senses, perceived by the subject as distinct, are activated simultaneously even though only one sensory channel is being stimulated. For example, someone with synaesthesia may also see the colour produced by a sound. In terms of the world population, it is estimated that the percentage of people who have this type of reaction is very low — in the order of four per cent — but among these are some very famous people, such as the artists Wassily Kandinsky

and Paul Klee, the writer Vladimir Nabokov, the composer Aleksandr Skrjabin, and the musician Frank Zappa.

Synaesthesia is a crucial factor whenever we talk about colours. Because colour conveys most of the information we receive from our surroundings. It is a strategic function for survival that has always been with us. Indeed our colour vision, interacting with olfactory and acoustic signals, simultaneously gives us a global perception. And this interaction between the senses is crucial, because our brain constantly processes the information transmitted by all external receptors. In everyday life, when we speak of synaesthetic perception we refer to those situations in which an auditory, olfactory, gustatory, tactile or visual stimulation is shared simultaneously by several senses. This convergence of different sensory stimuli can cause a positive or negative impression, which is decisive in the formulation of our judgement. This is demonstrated by an amusing anecdote told by the great Johannes Itten — painter, designer, writer, lecturer at the Bauhaus and one of the greatest colour theorists of the 20th century — in his most famous book, *The Art of Colour* (1961). An industrialist invited a group of guests to dinner and welcomed them into a room filled with inviting aromas from the kitchen. However, when the guests were seated at the table laid with all kinds of delicacies, the host turned on a red light. The meat instantly took on a nice bright colour, appearing fresh and juicy, but the spinach took on a blackish tinge and the potatoes turned red. The diners barely had time to be surprised when the light turned blue, making the roast appear stale and the potatoes rotten, resulting in a general loss of appetite. At that point, a yellow light was switched on, the red wine looked like a dark oil, faces turned yellowish like those of corpses, and some particularly sensitive ladies hurriedly left the room. No one dared taste the food, not even a bite, even though everyone realised it

was only the coloured lights that were to blame. At that point the landlord switched the white light back on and appetite and good spirits returned.

The perception of colour, in short, involves our five senses which are coordinated by another factor, one we can call the sixth sense, and which is psychological in nature. When faced with colour, all information flows into a unified perception where experience and instinct merge. Colour in this way can also influence our perception of temperature, volume, weight, the passage of time, and noise. And indeed we are used to referring to colours with classic synaesthetic metaphors: a sweet pink, a heavy brown, a strident red, a rotten green, a deep blue, a hard grey. Here then is the synaesthetic palette, or the ways in which colours interact with our senses.

COLOUR
AND TEMPERATURE

We are used to dividing colours into two main categories: warm and cold. To the former belong yellow, orange, and red. They are those that promote adaptation processes and vitality, that have a stimulating and exciting power, that arouse joy, strength, and passion. Conversely, we refer to blue, violet, and azure as cold; they have a sedating, calming power. They convey calm, rest, but also sadness. Green and purple, being in a balanced position between warm and cold colours, can be described as lukewarm.

This classification derives precisely from the feeling one gets when looking at colours. Thus, for example, yellow and red are considered warm because we associate them with the colour of the sun and fire, so looking at them we *feel* their warmth, while blue is

considered cold because it brings to mind water. The distinction between warm and cold, however, depends very much on the context in which a colour is found: it is one thing to see purple on the palette next to blues, another to see the same purple next to reds or oranges: in the first case it will be a warm purple, in the second a cold purple.

There are many experiments that have shown how colour can influence the perception of temperature. In 1971, in a clinic in Arlesheim, Switzerland, Dr. Hans Jürgen Scheurle conducted research on colour therapy by evaluating the effects of being in two rooms decorated entirely in a single colour (ceiling, walls, floor), one blue and the other red. By measuring blood pressure, pulse, respiratory rate, and assessing bodily and psychological reactions, he saw that people had many different reactions. In the blue room, for example, the volunteers perceived a lower temperature than the volunteers in the red room, even though the room temperature was identical. After a certain amount of time, two of the patients participating in the experiment felt significantly warmer in the blue room. The other participants, while not experiencing the same sensation of heat, reported that, after a certain period of exposure to both the initial warmth of the red room and the cold of the blue room, their bodily sensations had returned to normal. Scheurle then hypothesised that, since the human body always tends to adapt to its environment, the feeling of warmth in the blue room was a normal reaction of the organism.

In short, we can also choose colours based on their ability to influence our perception of the temperature of an environment and try to use them to achieve specific sensations.

Warmth

This is suggested by the spectrum of yellows, oranges, and reds. The more saturated and brighter they are, the more they convey the idea of warmth.

Cold

Whites, blues and azures, but also greens with a high percentage of blue, create cold environments.

A mild climate

This can be achieved by combining both warm and cold light tones that lessen each other's impact and create a more balanced atmosphere.

A hot environment

Combining a warm colour, such as burgundy, with a saturated orange creates a strong contrast of brightness with incandescent effects.

A refreshing atmosphere

Cool colours, from blues to greens, with a high degree of saturation and brightness instil a pleasant feeling of freshness.

INFLUENCES ON TASTE

An experiment conducted in 2012 by the Polytechnic of Valencia and the University of Oxford showed how the colour of the container can affect the taste and aroma of food and drinks. Fifty-seven volunteers were given the same type of hot chocolate to drink in cups of four different colours: white, cream, red, and orange.

The "guinea pigs" decided that the best-tasting drink by far was the one in the orange cups, followed by the cream-coloured ones. The hot chocolate was replaced by whisky in another Oxford University experiment, this time to demonstrate how the colours of three different rooms can influence the perception of taste. The first room was dominated by green tones, it was full of plants and there was the smell of cut grass in the air. In the second, the deep reds of the rounded-edge furniture gave a sense of softness, and a sweet scent hung in the air. The third room was brown, entirely lined with wood panelling, the smell of wood smoke pervading the air, and the sound of a crackling fire in the background. Although the participants were aware that they drank the same whisky, they said it had a different taste in each room, and they preferred the one drunk in the wooden environment. In 2014, research conducted at the University of Arkansas showed how blue can reduce appetite. The 112 participants taking part in the experiment were separated into rooms lit with different-coloured lights (white, yellow, and blue), and were not served dinner. The next morning, at breakfast, although everyone said the food was tasty, those who had stayed in the blue-lit room ate less than the others. This phenomenon is easy to explain because food is not commonly blue and the colour has has always signified potentially toxic or spoiled food to humans.

There are so many examples, research in the field is vast and has given us a number of indisputable facts. For example, that yellow containers enhance the taste of lemon in sodas, while cool colours, such as blue, give the impression of a more thirst-quenching drink. Warm pastel shades are associated with pleasant taste sensations, recalling a mostly sweet and juicy flavour. Sweet par excellence is the pink colour of candy. The combination of dark colours in tonal contrast, with similar saturation and brightness, such as

bottle green and brown, arouse in us the sensation of a bitter taste. Bitter is the green of unripe fruit, the deep brown of coffee or cocoa beans. Warm, bright colours recall the colour of chilli peppers and evoke a spicy flavour. The colour that above all represents the adjective acid is a green composed of mostly yellow and a touch of blue, juxtaposed with a darker green reminiscent of the colours of acid compounds. The combination of blue and white evokes a salty taste, as these two colours are reminiscent of seawater. So, here is a list of the more common taste/colour combinations:

Sweet
All the bright reds, light and delicate pastel colours, such as pink, pale apricot, peach, and flamingo pink.

Salty
Warm shades of yellow, such as saffron, combined with any blue.

Spicy
Warm, dull yellows and browns.

Acid
Greenish-yellows and, conversely, yellowish light greens (acid green).

Sour
Lemon yellow and green express the sour taste of the fruit.

Bitter
Less bright and vibrant shades of green, combined with darker, less saturated browns with dominant hints of green.

Pungent

Vermilion red (a very bright red somewhere between orange and purple) and more generally contrasting red and orange colours. Adjacent warm colours with not too high a degree of saturation such as paprika red.

OLFACTORY ASSOCIATIONS

Smell is the oldest of our senses. It was already present in our brain long before it evolved into its current form and function. It is a much more powerful sense than we think and actually we humans can identify about ten thousand different categories of odours. And we store them in our memory for a long time. A study by Rockefeller University in New York showed that people can remember thirty-five per cent of what they smell, five per cent of what they see, only two per cent of what they hear, and a mere one per cent of what they touch.

The fact is that information from the sense of smell is processed by two different areas of the brain: the limbic system (hippocampus and amygdala) and the thalamus. The first is located in the oldest and deepest part of the cerebrum (the largest part of the human brain) and controls emotions, moods and instincts. It also plays a role in the memory process, in particular in the mechanism of mediation between memory, behaviour, and emotions. The thalamus, on the other hand, is involved in the cognitive interpretation of the olfactory stimulus. That is why the association between colours and smells is perhaps the easiest to understand and control. It is therefore no coincidence that pink, lavender, pale yellow, and green are the classic packaging colours for cosmetics and body

care products. They awaken pleasant olfactory sensations in us, linked to the scent of flowers. But at the sight of colours such as reddish orange, brown in its most varied shades, dry greens and saffron yellow, we have a tendency to perceive a strong, pungent smell like that of spices. Dark brown tones are associated with aromatic products such as chocolate, coffee or tobacco, whereas blue shades combined with white have little effect in arousing olfactory sensations, and for this reason are colours regularly found in ceramic or porcelain tableware.

Below are the categories of colours that can evoke specific olfactory sensations:

Scented

The entire range of violets: from lilac to lavender, from wisteria to cyclamen to purple.

Unpleasant

Easily associated with dull greens, like mould green, and greens closer to brown, like rotten green, dark moss green, and khaki.

Aromatic

Stemming from an almost monochrome palette that veers from dark brown towards tobacco and chocolate brown, combined with moss green and mustard.

THE SENSATION OF TOUCH AND TEXTURE

Can a colour really awaken a tactile sensation in us? Can we really perceive a surface as dry or wet, smooth or velvety, without touching it? Yes, of course. And, indeed, warm, bright and not highly saturated colours, such as sand and ivory, which convey the feeling of dryness, are the typical colours of the trench coat, or the mackintosh in perfect English style. The impression associated with green, the colour of foliage, goes from polished to moist, just as it does with grey, the colour of stones and rocks. As green turns to the blue, our tactile impression becomes increasingly watery, and the idea of smoothness turns into fluidity. Whereas low saturation and less bright colours give a sense of materiality and heaviness, a greyish brown or burnt sienna is reminiscent of soil, tree bark, rock surfaces, and sand. Ultramarine blue, purple, and crimson, on the other hand, are tasked with restoring a velvety appearance. Here is a list of the proven tactile effect for every colour range:

Soft
Belonging to pastel, low saturation and very bright tones, from pink to apricot, from yellow to sky blue.

Wet
Stemming from cold, bright colours, such as light blue, opaque sea green, and turquoise.

Hard
Evoked by colours with low saturation and low luminosity, such as blacks and greys with very dark tones, namely lead grey, blue grey or anthracite grey.

Dry

Dominated by warm, bright, unsaturated colours, such as beige, ivory and sand.

Textured

It is down to all the dark and low saturation browns and greens to reveal the roughness of surfaces.

Smooth

Light grey and metallic colours with a satin finish fully reveal smoothness.

THE PERCEPTION OF SOUND

Anyone who has ever walked into a recording studio, or perhaps seen one in a film or on TV, will undoubtedly have noticed that the soundproofing panels on the walls are usually dark in colour. But the brightness of the colour is not the only parameter to be considered when it comes to sound perception. What affects us most is its temperature. Studies on the links between colour and sound, in particular those carried out by the German biologist and psychologist Heinrich Frieling, show that warm colours amplify sound sensations, whereas cold colours dampen them. Another classic example is green, which influences our perception of noise by muffling sounds, and is in fact often used in road noise barriers. In particular, light green is used, which is good for softening the perception of high-pitched and shrill sounds, whereas darker shades dampen more low-pitched sounds. So, if we want to aid our hearing with colours, we ought at least to know the tricks to control the four basic sounds:

Low Sound
To best handle it, use dark and cold tones with low saturation.

High sound
This requires light and warm colours, mostly found in the red-orange range.

Muted sound
Achieved with all greens in the range, such as bottle green, pine green, Veronese green, olive green, dark grey-green and sage green.

Vibrant sound
Enhanced by the combination of complementary or polar colours with an equal degree of saturation, such as light fuchsia and apple green, or purple and yellow.

THE TIME DIMENSION

The American journalist Linda Clark, who specialises in nutrition and natural medicine as well as being the author of several books on colour therapy, reported on an interesting experiment carried out in two different rooms, one red and one green. A group of people were put inside each room where there was no clock. At the end of the session, the people in the green room thought they had been inside it twice as long as they actually were, and certainly much longer than those in the red room. Colour is indeed capable of altering our sense of time. Warm colours generally result in an overestimation of the passage of time, while cold colours produce the opposite effect, in other words, a sensation of time dilation. The explanation is physiological in nature: warm tones, such as

red, cause a slight acceleration of the heartbeat and give rise to a sensation of speed. This has been demonstrated by several studies focusing on the possibility of influencing the human perception of time using brightness and colour saturation. In one such test, the participants in a meeting held in a brightly coloured room felt that the meeting lasted forty-five minutes less than those in an identical meeting held in a more softly coloured room. So, we can slow down or accelerate the passage of time with certain colours.

Slow pace
Captured with cool, dark tones, but also with low-saturation, lacklustre browns and colours opposite the red range, such as dark, low-saturation blue or very dark grey.

Speed
Powered by warm colours, especially red and yellow.

THE APPRECIATION OF WEIGHT

The weight of a colour is a sensation that is at the other end of the scale to brightness and clarity. By definition, therefore, the darker the shade, the heavier it appears; the lighter it is, the more delicate and rarified it seems. And, in actual fact, we can easily see that black objects appear to be heavier than white ones. It is therefore no coincidence that, in order to communicate the sense of a luxury object's inherent solidity, as opposed to insubstantial mass-produced products, design has made use of very dark colours in recent years. In a nutshell, we can therefore say that lightness and heaviness are also a matter of light.

Heavy

This effect is achieved with dark, textural colours, such as blacks, browns and very dark greys.

Light

This sensation is linked to pastel colours with a high degree of brightness.

A QUESTION OF SIZE

Dressing in black, dark grey or deep blue to go down, if not a size, at least a few centimetres, is a well-known and proven technique used by people of all ages. And rightly so. Because colours definitely influence our perception of the volume and size of an object, as well as an environment. Light colours tend to expand measurements, while dark ones reduce them. And because of this, light-coloured rooms always seem more spacious and bright. But it is not just a question of colour per se. What also plays an important role is the juxtaposition of different colours and the relationship with the context in a play of chiaroscuro that significantly alters our perception of the true dimensions.

Big

A light-coloured object placed on a dark background will appear much larger than it actually is.

Small

In contrast, a dark object placed on a light background will appear much smaller.

THE SENSE OF SPACE

Every colour occupies a position in space in relation to the others. In other words, our perceptual system tends to assign colour a precise spatial location. And so cold colours appear transparent and light, and seem to take a back seat. Warm ones, on the other hand, appear dull and dense, giving the impression of being in the foreground. However, if we reverse the brightness values, this rule is also completely reversed. For example, blue, when juxtaposed with impure warm colours, tends to perceptually advance rather than retreat. Because more saturated colours tend to prevail when juxtaposed with impure colours. Here, then, are the basic principles for using colour to bring spatial elements, such as the walls of a room or corridor, closer or move them further away:

Far
Cool colours tend to be spatially in the background.

Near
Warm colours have a tendency to prevail and come to the fore.

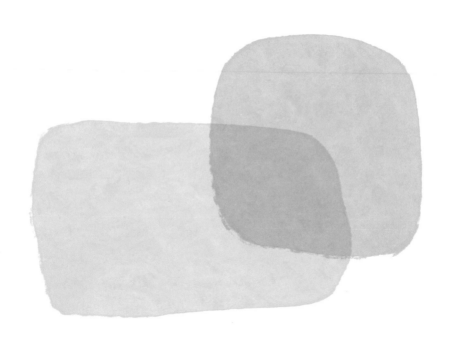

With the term colour we identify both our body's reaction to a colour stimulus and the specific wavelengths of light radiation. But none of this is enough to explain the fascination that colours have always held for human beings and the meanings they have taken on over the centuries and millennia. Because colours are also a complex set of sensations and emotions, associations of ideas and communication practices, cultural stratifications, artistic and religious sensibilities, taste, styles, fashions, and behaviours that human beings have developed throughout their evolution and history. Each colour has its own physical characteristics and the capacity to interact with our body, but it also has its own long history, value, and a world of meanings.

LADIES AND GENTLEMEN, THE COLOURS

YELLOW, RED, BLUE, GREEN, ORANGE, PINK, INDIGO, PURPLE, BROWN, GREY, GOLD, WHITE, BLACK

Before delving into the world of the meanings and stories of individual colours, we should remember that not all colours are the same. There are two main categories: primary and secondary. Primary colours can be called absolute colours, because they are not obtained by mixing and are in fact the basis from which all other colours are obtained. They are yellow, red, and blue. Secondary colours are the result of the combination of two primary colours. These are orange (yellow + red), green (yellow + blue), and violet (red + blue), which of course in turn can generate many different shades depending on the percentage ratio of the two primary components. To go further, we could also speak of tertiary colours, those arising from the combination of primary colours, but in different proportions. Then there are the combinations of primary colours with secondary colours, like yellow with green or orange, red with purple, or blue with green, but these are actually gradations. Out-of-category colours, which complete the palette, are black and white, known as neutral. Only indigo remains, an enigmatic hue that few can recognise, so much so that its wavelength seems not to be perceived by everyone in the same way. Yet it is one of the colours that make up the solar spectrum and which we are used to seeing in the rainbow. Precisely for this reason it is fundamental in alchemical culture, where it is present in the image of the Cauda Pavonis (the representation of wisdom composed of the seven colours of the iris distributed along the arc of a peacock's tail), as well as in Oriental culture, characterising one of the seven chakras (the energy centres located within the human body that also correspond to the colours of the solar spectrum).

2.1 YELLOW

The majority of pencils produced and sold worldwide are yellow. This is not a recent phenomenon. It dates back to 1889, the year of the Universal Exhibition in Paris. Of course pencils had already been around for a couple of centuries, but they were made of rough wood and were dark in colour. But, on the occasion of the inauguration of the Eiffel Tower, the Czech company Hardtmuth Pencil decided on yellow as the colour of its new pencils made of high quality graphite. Because yellow stood out, and in Siberia, where the graphite was extracted, it was a colour associated with luxury. To underline the message, the new line of pencils was named Koh-I-Noor, after the most famous diamond in the world. It was such a success that, not only did the company end up taking the name Koh-I-Noor Hardtmuth, but all their competitors started producing yellow pencils too.

The strength of yellow is undeniable. Universally associated with the sun, it is considered the happiest of colours and is perceived by the human eye as the brightest of all. Just like the sun, it conveys vital and positive feelings, it speaks to us of energy, creativity, and action. From a psychological point of view, yellow is an expansive and communicative colour that expresses extroversion, a sense of freedom, and wealth. The term derives from the Old French *jalne*, which in turn originates from Latin *galbinus*, denoting a pale yellow with shades of green. There are in fact two main dominants in the yellow range: a warmer one (cadmium yellow, golden yellow, ochre) and a cooler one (lemon yellow, canary yellow, acid yellow). But being a light color, when it loses its brightness it ceases to be yellow at all. Its polyvalent nature was captured with great sensitivity by the famous painter Kandinsky, who described it as "the happiest of colours, which, however, when it is too intense, reminds one of a madman's laughter. Yellow is difficult to turn off,

it always exceeds the limits within which you would like to confine it."

In fact, we can consider yellow as the "highlighter" colour par excellence and for this reason, also from a semantic point of view, it plays a fundamental role above all in the urban environment, and particularly in road and safety signs. In corporate communication, its strength makes it ideal as an emblem of joy, and also as a means of instantly identifying widely available products and services. In the 1950s, Kodak chose it to package all its photographic films, thereby representing the possibility of capturing happy memories in time. More recently, 3M has built the success of Post-it notes, the removable adhesive labels, on a lighter shade of yellow.

Yellow, as we have seen, attracts the eye more than any other colour and, precisely because it is so highly recognisable, it can assume negative connotations. A yellow flag on a ship's flagpole, for example, is the sure sign of the danger of contagion and signals quarantine. Yellow, lest we forget, was the Star of David that "branded" Jews during Nazism. In medieval painting, where the beauty of a colour was measured by its brightness, the preciousness of the work of art, at least as far as panel painting was concerned, was manifested primarily by its gold backgrounds. With the rise of gold, yellow took on a negative meaning, being characterised as a degeneration of gold's qualities. The pairing of yellow and green colours was even used to distinguish fools or buffoons, and the more yellow tended towards green, the more it was considered negative. In Christian iconography, traitors were connoted by yellow or greenish-yellow, and indeed Giotto depicted Judas draped in a yellow cloak in the fresco cycle of the Scrovegni Chapel in Padua. But it is also true that, in a positive sense, yellow robes were ascribed to St. Joseph and St. Peter, for example. And ancient folk legends associate yellow with Luciferian sulphur to indicate the

diabolical or to describe negative feelings, such as envy, cowardice, and anger. Perhaps this is also why it is considered to be the colour of jealousy, and according to the "flower etiquette" in vogue in the 19th century, giving yellow roses meant expressing the fear of losing a loved one.

The fact is that yellow, readily available in nature in the form of both lime and stone, from straw to ochre, has been used since prehistoric times. Among the oldest pigments is Naples yellow (formerly Egyptian yellow), widespread since the time of the Egyptians and the Assyrians. Yellow has crossed all epochs and cultures, becoming enriched with a host of meanings. But perhaps the most emblematic yellow remains that of Vincent Van Gogh. Chrome yellow was the lifelong obsession of the Post–Impressionist painter plagued by endless mental health problems. He was known to literally feed on the colour, eating it out of the tube in an attempt to imbibe that same joy that it brought to his eyes. Chrome yellow is the colour that recurs in the subjects of his most famous and tormented works: the House in Arles, the Sunflowers, and the Wheat Fields. Van Gogh is said to have obsessively coloured his world with a predominance of yellow because a combination of absinthe and epilepsy medication caused him to suffer from xanthopsia, a visual disorder that makes white objects appear yellow and dark ones violet. Van Gogh's yellow expresses the essence of warmth and hope. But, in the end, it also gave free rein to his inner anxieties. What we see today is probably a degeneration of what once was, because lead chromate yellow pigments, precisely his chromium yellow, have poor chemical stability and are very sensitive to light. The beauty and intensity of the hues have been dulled over time by a marked darkening.

EFFECTS OF YELLOW IN INTERIOR SPACES

On ceilings, it gives a feeling of brightness (but only in pastel tones).
On walls, a yellow with orange tones infuses warmth, but can cause irritation if too saturated.
On floors, it is uplifting and frees the mind.
Yellow illuminates and enlivens rooms, but it is the depth of colour that makes it warmer and more energising, or cooler and calming. Bright, warm shades, combined with fresh, unsaturated tones, create cheerful, cosy environments. All yellows in the range endow dimly lit spaces with maximum visibility. But if pure yellow is put on a white background, it loses clarity.
In terms of time, it can give a sense of dynamism and acceleration, depending on the temperature and saturation level.

2.2
RED

Exciting, vibrant, stimulating, red incites us to action. Less present in nature than blue or green, it has, however, always been the source for conveying information crucial to survival. It is no coincidence that it is the colour universally recognised and used to represent the heart, the beat of life. The etymology of the word "red" is related to the Indo-European root *rudh-* or *reudh-* which in Sanskrit is used as a noun, *rudh-iram*/blood, or as an adjective meaning red. It is the same root that we find in the Latin words *rubens*, *ruber* and *rufus* /red, and in Proto-Germanic languages, *rauthaz*/red, from which comes the Anglo-Saxon *red* and the German *rot*. So red originally meant "the colour of blood", and this meaning still holds with every one of us, linking the colour to passion, impetus, and vivacity. In many cultures, as a legacy of the ancestral division of labour between males (hunting) and females (caring), the male essence of red is linked to courage, and the female to love. Red is also the original idea of fire, the fundamental tool of life, the mainstay of evolution, the force that transforms, purifies and protects.

Over the centuries and across cultures, red has taken on certain indelible traits which are still with us. For example, its being auspicious. It was associated with good fortune as a symbol of fertility in Ancient Greece and Rome, as well as China. Red is a superstitious colour even today, often used when dressing up for a special occasion, like New Year's Eve (the tradition was apparently already in vogue in the Rome of Octavian Augustus), or for more everyday common uses, such as wearing or carrying a good-luck charm.

Its immense physicality has always allowed red to occupy a central position in art and architecture. The evidence is endless and goes back to the Stone Age cave paintings found in the Chauvet Cave in France, where animals are painted in red ochres. But the most famous ancient red we have inherited, one which is still in vogue to-

day, is undoubtedly Pompeian red. In the ancient Roman city it is present everywhere, a recurring element and a distinctive feature. It colours details, frames, pilasters, perhaps an inscription, or it covers entire walls. It is a very characteristic type of red, imposing, lively, brash to the point of being the perfect backdrop even for the meticulous depictions of the intense sexuality of the time. When the ancient city was rediscovered in the mid-18th century, it was Pompeian red, with its opulence, that struck the imagination of Europe's nobility and the wealthy, who wanted it in their residences to emphasise prestige and power. And, of course, because red is also the colour of power.

Its symbolic meaning and psychological significance are linked to two precise physical characteristics: red is the first colour in the colour spectrum (and the rainbow). Our perceptual apparatus, in order to focus on red, must adapt to its longer wavelength. Converging on the crystalline lens, red shifts forward the focal point of the eye, located naturally on the retina, making objects of this colour appear closer. That is why communicating with red is very useful for alarms, warnings, and prohibitions. We see it immediately and it puts us in a state of alarm.

EFFECTS OF RED IN INTERIOR SPACES

On ceilings it is experienced as an intrusion, infusing heaviness and even annoyance.

On walls it can be aggressive and give a sense of a looming presence.

On floors it strikes our attention and confers a certain pomposity.

Usually, red is used in interiors as an accent, serving to highlight elements. More rarely does it become a dominant colour.

If saturated, it should be used with extreme caution, because its dynamism catalyses all our attention to the point of being overstimulating for anyone in that space. All the more so since the temporal dimension in red-dominant environments is accelerated.

2.3
BLUE

Blue has been shrouded in mystery over the centuries. Despite being among the most widespread colours in nature, from the sky to the sea, there was no mention of it: not in the culture of Greece or China, not in that of the Vikings or the Jews, not even in that of India. In the 19th century the German philologist Lazarus Geiger for many years studied the Bible, the Koran, ancient Chinese stories, Icelandic sagas, and even Vedic hymns. But as he himself wrote: "There is one thing no one will ever learn from these ancient songs... and that is that the sky is blue." Even Homer, in the Odyssey, describes the sea as "black as wine". As if blue did not exist and manifested itself as a dark shadow or a variant of green. Recent experiments have shown that until humans became familiar with blue, and gave it a name, they did not even see it in the landscape, did not recognise it, did not observe it. With one exception, the Egyptians, who had produced blue three thousand years before Christ: their blue, made of copper tetrasilicate and considered the first synthetic pigment in history, was used to decorate statues, buildings, objects, and fabrics, and was sold with great success throughout the Mediterranean basin to peoples who did not have a name for it.

Traces of this mystery are more evident than ever in the etymology of the word "blue". In ancient Greek, *kyanós* (the root of cyan, today the name for the blue complementary to red) was used to denote a dark shade ranging from blue to green, while the term *glaukós* referred to the brilliant colour of the sea. Whereas the term "blue" originates from *bláo* in the ancient language of the Franks, which in turn derives from the Proto-Indo-European *bhle-was*. The root *bhle-* means blue, but also the colour of light, which in Latin became *blavus*, faded.

What we can say to explain this huge misunderstanding is that it is indeed not easy to define blue precisely because its range is

among the widest and includes shades tending towards indigo, green, and black. Frank Mahnke often said, "Blue can be considered a sort of conciliator between all colours." Perceptually, the range of blues (together with that of greens) is optimal, as it converges directly on the retina. And precisely from this physiological peculiarity derives blue's psychological power as a relaxing colour. Even in the history of art, blue came late, not only because of the difficulties in recognising and naming it, but above all because of the complexity and cost of the processes involved in obtaining the pigment. It was not until the 11th century that its full range became established in art, reaching a peak in the Renaissance. It is in medieval Christian iconography that the Virgin Mary's robe takes on shades of blue, and the "Chartres blue", the characteristic colour of the stained glass windows of Chartres Cathedral, dates back to this period: a luminous blue obtained by colouring the glass paste with cobalt oxide. Whereas Giotto's blue was obtained from lazurite, a mineral that came from Afghanistan. The entire Scrovegni Chapel in Padua is topped by a starry vault of delicate blue. It is a crucial moment in the history of art that marks the transition from the gold background to the blue background. But it was not until 1956 that blue reached its apotheosis when the French artist Yves Klein presented "the most perfect expression of blue", a monochrome work whose essence was colour: a saturated ultramarine tending towards Newtonian indigo, which was later patented under the name IKB, International Klein Blue.

Blue is a sober and elegant colour, suitable for every context, and this is also the reason for the extraordinary popularity of jeans. Denim is the perfect fabric for blue, because it fades as the fibres wear, therefore running through the colour's entire range over time. In the field of communication, blue is by far the most popular colour: it instils trust and confidence, which is why, in politics

as in advertising, tones ranging from azures to blues are used when the aim is to inspire approval.

But blue also has its negative aspects. If we think about it, the blues is the only musical genre that is identified with the name of a colour. The blue of the night, of melancholy, of intimacy, and depth of feeling. And then, in English, expressions like "being blue" or "feeling blue" are used that mean being sad, feeling sad.

In interior design, blue should be used with caution because, being a cold colour, it can affect the climatic perception of an environment or evoke a feeling of excessive stillness.

EFFECTS OF BLUE IN INTERIOR SPACES

On ceilings, if light in colour it appears airy, if dark it is looming.
On walls, when it is light it is cool and distant, when dark it is very deep.
On floors, if it is light-coloured it aids effortless movement, if dark it increases resistance.
In general, on large surfaces, dark tones are cold and gloomy, intermediate ones give a sense of depth, while tones that are too light can cast annoying reflections onto objects. The temporal dimension in blue-dominant environments expands in proportion to the brightness and saturation.

The word "green" comes from the Latin *viridis* which in turn comes from the verb *virere*, to be green, to become green. Its ancient origin goes back to the Indo-European root *ghvar*, and then *var*, meaning to be green (or yellow) and, in a broader sense, to shine. Green therefore means shining colour. And indeed, it is the colour of the self-regenerating natural kingdom. Strongly associated with life and growth, it is widely felt as a positive colour and is also relaxing, because our perceptual apparatus has adapted to its strong presence in nature. As we have seen with blue, the green range is also optimal in terms of perception, as it is focused by the eye exactly on the retina. It is precisely because of this physiological peculiarity that it has a calming effect on the nervous system, and Heinrich Frieling, one of the most distinguished scholars of human reactions to colour stimuli, points to green as the colour that best dampens the perception of sound.

Green has a strong religious significance; it is the symbolic colour of Islam because this was the colour of the cloak worn by the prophet Muhammad as he led his people to the promised land, a place of lush fertility. In Eastern philosophies, it is associated with the fourth chakra, the heart energy centre, and so it stimulates the noblest feelings and brings love. In Japanese culture, it symbolises the future, youth, energy, and eternal life. It is also the symbolic colour of Ireland where it is associated with the Catholic religion, the country's iconic shamrock, Celtic culture, and fairies, who, according to tradition, are enamoured of the colour green. There are many shades of green and just as many meanings that this colour assumes in our imagination. We associate it with hope, life, youth, health, money, nature, energy, and freshness, but also with good and bad luck, jealousy, envy, poison, acid, and even extraterrestrials.

Green, which comes from the combination of yellow and blue, is ambivalent: it can appear warm and positive, like fertile nature, but also cold and sad, or even alien. When properly calibrated, it instils calm, helps reduce mental stress and quells the accelerated rhythms of our brain, as well as aiding concentration.

EFFECTS OF GREEN IN INTERIOR SPACES

On ceilings it has a protective effect, but with unpleasant reflections on the complexion.
On walls it conveys freshness, security, calmness; but it can appear irritating if acidic.
On floors it is relaxing; if it turns to a cool tone, it promotes concentration.
Equidistant from blue and yellow, green is the mediator between hot and cold. Not too cold or dark tones, such as greenish blue, are very versatile.
Beware, however: what looks like a perfect colour during the day may be less convincing when it gets dark, because green is not easy to illuminate.
The temporal dimension in green-dominant environments expands or contracts in proportion to temperature and saturation.

2.5 ORANGE

n Italian, *Arancione* or *arancio* can be used for the colour orange. And the connection with the fruit of the same name cannot be escaped. The term comes from the Sanskrit *nāgaranja*, "fruit liked by elephants", which later evolved into the Persian Arabic *nārang̃*. Orange is a warm, bright, energetic and vibrant colour. It evokes shades of fire and the sun, and is therefore associated not only with the idea of warmth, but also most strongly with energy and vitality. It is scarcely present in the liturgies of monotheistic religions but is sacred in the East. In Hinduism it expresses asceticism and the renunciation of material goods, in Buddhism it is the colour of enlightenment, while for Confucianism it represents transformation.

Orange, in short, combines the strength of red with the brightness of yellow. It is a changeable, vital and joyful colour, but can be at the same time as poignant as autumn and as melancholic as a sunset: in its most vivid version it is bright and reflective, in less saturated shades it can appear muddy or even dry. Like any colour, it is capable of provoking physiological and psychological reactions in us, it increases blood pressure (thanks to its red component) and has a stimulating effect on activity and movement.

Its expressive power makes it suitable for all kinds of applications in a wide variety of fields, from security signs to basketballs, to the uniforms of inmates in many American prisons, who thus become easily identifiable in the event of an escape. This ability to attract attention also makes it one of the most used colours in the world of communication. And thanks to its natural ambivalence, it is considered suitable to represent both consumer products and the most sophisticated and sought-after luxury goods.

At least two categories of artists owe much to orange: Vedutists of every era, who used it to paint fire, the sun, the setting sky, and autumn vegetation, and to give intensity to their compositions, and

Futurists, who chose it as a symbol of progress and "revolutionary" inventions because of its dynamism, to be contrasted with shiny reflective metal.

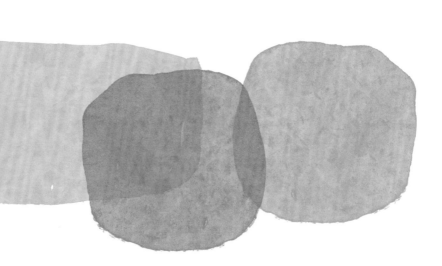

EFFECTS OF ORANGE IN INTERIOR SPACES

On ceilings it has a stimulating effect, it draws attention.
On walls it gives warmth and brightness.
On floors it stimulates activity and movement.
Less catalysing than red and less bright than yellow, orange conveys dynamism and is especially suitable for highlighting other colours. Pastel shades induce cheerful and friendly moods. The temporal dimension in orange-dominant environments is accelerated, although less so than in red ones.

2.6
PINK

A symbol of romance and beauty, pink is linked to delicate and positive feelings. We all hope for a rosy future, don't we? Traditionally we associate it with the female, as opposed to the blue of the male, particularly in childhood. Less well known are the two sides of the pink soul. Being obtained by mixing red and white, in bright tones it inherits the aggressiveness of the stronger tint. In a more vivid pink painted environment, therefore, we do not feel so comfortable, there are no feelings of enveloping calm, and it becomes a struggle to adapt to the space.

Pink has the ability to also stimulate taste and smell, bringing to mind sensations of sweetness and softness. But in the imagination it is also one of the colours of eccentricity, especially in its fuchsia and magenta variants. And the name rose pink no doubt comes from the fact this colour can assume the same variety of tones as the flower. In general, pink is included in the range of light reds, but then we are used to talking about an infinite number of shades: powder pink, peach pink, cotton candy pink, flamingo pink, sorbet pink, flesh pink, salmon pink, shocking pink... in short, from the lightest beige to the most intense coral.

It is also because of these infinite possibilities that pink is firmly present in product design, like interiors, where generally brighter shades and more sophisticated versions, such as antique pink, are preferred.

EFFECTS OF PINK IN INTERIOR SPACES

On ceilings it gives a sense of delicacy.
On walls, if brightly-coloured it can be inhibiting and aggressive, if lighter and softer it becomes decidedly saccharine.
On floors its delicacy becomes excessive.
A well-balanced pink instils a sense of comfort and softness, but if the red component is predominant, it may convey restlessness. However, if it appears too sugary, it can be effectively counteracted with grey.
In general, with pink our physiological reactions are intensified in proportion to its red component.

2.7 INDIGO

2.8 PURPLE

As "violet" the colour refers to the flower of the same name and, from a chromatic point of view, purple brings together two physically and psychologically opposite colours: red (earth and flesh) and blue (sky and spirit). Warm or ambivalent, it can therefore be characterised by a cold (bluish) or a warm (reddish) dominant tone. In ancient times its fortunes wavered. It was banned in ancient Egypt because it was considered magically dangerous. In the Roman and Byzantine empires it was a preserve of the emperor. It became a symbol of the Christian liturgy and still today is considered a colour strongly linked to the spiritual sphere, mysticism and interiority.

There is no shortage of negative suggestions in its symbolism. Purple can represent penance and mourning, or misfortune and sadness. This is why it is not widely used in corporate communication, with the exception of products related to the female sphere, such as body care and intimate hygiene. Lighter tones closer to red are more common, shades that communicate sensuality, seduction and mystery, as well as evoking a pleasant olfactory sensation linked to the scent of flowers. From a tactile point of view, purple evokes a velvety sensation. In terms of taste and hearing, the associations of the scholar Heinrich Frieling are linked to the soporific aspect of purple, with its sweet, heavy taste and sad, deep sound that becomes weak and restrained in violet. Solemn and enigmatic, it has had mixed fortunes in fashion. Eccentric and transgressive, it characterises exclusive or, more often, ironic and bizarre clothing.

EFFECTS OF PURPLE IN INTERIOR SPACES

On ceilings it behaves like every other colour: if light-coloured it is lightweight, if dark it is heavy.

On walls, when pale it can actually evoke fragrances, when dark it is depressing.

On floors, if light it appears eccentric, if dark it induces discomfort.

Rarely used in architecture, the range of lighter shades of purple help create intimate environments with a special atmosphere. A lot also depends on whether it is predominantly warm or cold. For example, its effect on the estimation of time varies greatly: with red dominating time accelerates, whereas with blue it appears to expand.

2.9 BROWN

A few years ago, the Australian government launched a huge campaign against smoking and commissioned a survey to find, if not the most unattractive, at least the world's most unpleasant colour. Why? To force tobacco multinationals to use it on cigarette packs and so discourage people from buying them. The respondents chose Pantone 448 C, a rather dull mix of brown and dark green. We do not know how things ended in Australia, but we ought say a few words in defence of a shade of brown that was chosen by Leonardo da Vinci for the Mona Lisa's robe.

Brown is not present in the solar spectrum, but it is constant in nature and widespread in our daily lives. Its name is derived from that of the chestnut, *marron* in French, and indeed this fruit comprises the full range of this colour. In its most positive sense, brown conveys an impression of stability, solidity, and consistency. Warm, bright and low saturation tones, such as beige and ivory, convey a feeling of dryness, like the highly popular sand colour, typical of the waterproof trench coat. Brown also generates many taste associations, being the colour of tobacco, chocolate, and coffee, whose aroma it recalls, which is why it is widely used in food marketing.

In interior design an excess of brown, even in the form of wood, can convey an old and dusty impression. Due to the effect of surface contrast — which plays on the gloss/matt ratio — the glossier tones, especially if greenish, are not very pleasant.

EFFECTS OF BROWN IN INTERIOR SPACES

On ceilings light-coloured wood gives a sense of solidity, and dark wood one of oppression.
On walls wood instils a sense of security, and the plain shade renders heaviness.
On floors it gives a feeling of stability and balance.
A colour closely related to nature, if brown is used as a plain shade it loses its expressive power. Wooden floors and terracotta nuances are most attractive. But if brown is dominant, cool, light shades should be combined to soften its warmth. The temporal dimension varies in proportion to its brightness and saturation.

2.10.
GREY

n the world of fashion, it is said that grey never lets you down. It is elegant, but also practical, a bit like black, but bright and, above all, enjoying a range of infinite shades, from pearl to anthracite, through to silver and the brightest metals. Perhaps no one goes so far as to say that grey is their favourite colour, but we all know how to exploit its positive aspects. After all, we use black and white to indicate extremes, the good and the bad, righteousness and evil, and we use grey precisely to recall the concept of balance: *in medio stat virtus*, virtue lies in the middle.

The name derives from the Old Saxon *gris* meaning dog-like, grizzled. And, of course, it is the colour of old age. But this does not mean that it is an entirely negative factor. Growing old also means gaining experience and becoming wise. Grey is a very common colour in nature and is also the most common shade in industrialised cities: grey streets, grey buildings, and grey cars. From a cultural point of view, it counterbalances green: the grey of the city against the green of nature, the grey of old age against the green of youth. But today it is also the colour of technology, the metallic shades with a satin finish of hi-tech design and the most go-ahead areas of the car industry. On the surface, grey conveys a feeling of security and solidity, but it has many drawbacks if used excessively, because what is grey is also commonly experienced as oppressive and boring, a symbol of conformity and standardisation.

EFFECTS OF GREY IN INTERIOR SPACES

On ceilings it looks shady.
On walls it can appear neutral to the point of monotony.
On floors it is entirely neutral.
In all its applications grey tends to appear neutral and consequently devoid of stimuli. Somewhere between light and dark, it does not lend itself to highlighting any elements and therefore cannot be used as an accent. Chromatic greys, that is those with a hint of colour, are more suitable for use in living spaces, endowing them with a certain character.

2.11 GOLD

Only a few years ago gold would rarely have been included in a colour chart for interior decoration. Too expensive and too gaudy. Today this is no longer the case, metals are part of the sample book of most paint and coatings manufacturers, and gold has gained a more elegant, refined, and sophisticated aura than in the past. Its colour changes gradually from a reddish hue to a light yellow to a pale green colour as the amount of silver content increases. What we call gold is in fact a ternary alloy composed of gold (at 750 per thousand) together with silver and copper in varying proportions.

The term "gold" derives from the Latin *aurum*, shining dawn, which in turn comes from the older *ausom*, a Sabine term from the Indo-European root *awes* (to burn, to gleam), and can be traced back to the Sanskrit *ushas* (resplendent). Gold has always been the attribute of the divine origin of power. It is the colour of Mithras in Persia and Apollo in Greece. And in Christianity the green palms of Christ on earth are replaced by a golden halo when he returns in spirit. A ductile and unchangeable metal, it is the symbol of royalty, eternity, and the indissolubility of bonds. The ancient Egyptians were among the first to use it as a pigment, but during the Byzantine era it found its greatest artistic expression in the mosaics of Ravenna, a celebration of the epiphany of Justinian and the Empress Theodora, accompanied by court figures depicted on lavish gold backgrounds to highlight their political and religious lineage.

EFFECTS OF GOLD IN INTERIOR SPACES

On ceilings, when it is light-coloured it provides a high degree of light refraction, when dark it feels heavy.

On walls it conveys excessive opulence.

On floors it instils an awkward sense of delicacy.

It has rarely been used as a dominant colour. Its high cost has limited its use to details, mainly to embellish religious buildings and royal apartments. Today this is no longer the case, but the fact that it is available at acceptable prices does not mean it ought be misused.

2.12 WHITE

White owes much to Isaac Newton. The British physicist proved that, although light appears white to us, it is actually composed of all the colours of the solar spectrum: red, orange, yellow, green, blue, indigo, and violet. He demonstrated this in 1672 with a simple experiment that became very famous: he passed a ray of light through a crystal prism which broke it down to reveal all seven colours and their intermediate gradations. A kind of artificial rainbow that also served to show that white is a colour with high brightness but no hue, as it contains all the colours of the electromagnetic spectrum. And that is why it is called achromatic. In short, white is not the absence of colour, but the *essence* of colours, not just from a symbolic, magical, and philosophical point of view, but also in terms of science, mathematics, and physics.

The colour of light is universally considered synonymous with spirituality, and in many cultures it is the symbol of wisdom, represented as the sum of all colours. For Aristotle it was the active element, whereas black (the shadow) was the passive one; a view later taken up by Leonardo, who defined white as "generative" in his treatise on painting. Eastern thought considers white to be the sum of the seven colours that correspond to the seven chakras (the energy centres in our bodies), just as alchemical thought (the precursor of chemistry before the advent of scientific thought) held that white, and therefore light, originated from the sum of the seven colours of Iris, the messenger of peace sent to earth by Zeus. White is also often the symbol of the priestly class and is associated with purity and chastity. In the West it is the colour of marriage, while in the East it is the colour of mourning.

White is bright, easy to match, and expands the perception of the volume of a space. Due to its ability to repel sunlight and keep rooms cool, it is the typical colour in Mediterranean architecture

and countries with a warm climate. To quote from Japanese writer Haruki Murakami's book, *Hard-Boiled Wonderland and the End of the World*: "It is easy to say white, but it can be refined or crude, every shade has a character of its own." Precisely. Because true white, the one codified by the various colour systems, may indeed be just one, but we often speak of milk white, cream white, ivory white, ice white, gardenia white, and even marshmallow white. The list is huge, with some paint manufacturers having more than 150 shades of white in their catalogue. All these colours, seen alone, appear white, but comparing them side by side in the paint catalogue reveals the lightest shades of yellow, grey, blue, pink, green, and violet. This helps to "switch off" the dazzling, and somewhat synthetic effect of the purest white, and give a softer, more textural aura to any surface, of a room as well as an object.

For some years now, the strength of white has also been at the centre of the debate on sustainability and care for the environment. At the 2009 St. James's Palace Nobel Laureate Symposium in London, Steven Chu — one of the world's leading experts on climate change — said that if roofs, roads, and pavements were painted white, a colour that reflects sunlight without absorbing heat, the level of global warming would be reduced. This idea actually comes from a study by Art Rosenfeld and other scientists at the Lawrence Berkeley National Laboratory in California, a state where white-painted rooftops on commercial buildings have been required by law since 2005. According to their calculations, changing the surface colour of the world's hundred largest cities could cut the equivalent of forty-four billion tonnes of carbon dioxide emissions.

EFFECTS OF WHITE IN INTERIOR SPACES

On ceilings it can create a sense of emptiness and appear aseptic.
On walls, it appears neutral, devoid of energy, and can cast grey shadows.
On floors, it is inhibiting and reduces motor balance. White brightens and enlarges rooms, but many of its effects depend on the overall context, the light, the other colours present, and the texture of the surface upon which it is applied. Its plain whiteness can in fact be easily compromised. For example, on an uneven, rough surface hit by an inclined light, micro shadows would form making it appear greyer than it is.

2.13 BLACK

love black because it affirms, designs and styles. A woman in a black dress is a pencil stroke", said Yves Saint Laurent. The designer who played with colours the most, proposing bold and surprising combinations such as red with fuchsia or yellow with purple, actually loved black deeply. Because, as he explained, "Black is the colour of a Renaissance portrait, the colour of Clouet, Agnes Sorel, the Court of Valois, Frans Hals, and Manet." Also thanks to Saint Laurent, today we consider black the colour of elegance and confidence, but also of rebellion and provocation. A passe-partout colour for any season and any occasion, which slims and tones as well. It lends a certain rigour to the style and is able to build a kind of barrier between ourselves and the world, revealing very little. It is no coincidence that it is the most chosen and worn colour among professionals in the world of fashion, design and creativity in general.

But it was not always so. The word "black" comes from the Latin *nigrum* (black, dark, gloomy, mournful), which in turn originates from the Ancient Greek root *nekrós* meaning dead, corpse. The original meaning is therefore negative and inauspicious. From a chromatic point of view, black is the absence of colour. We can define it as the visual impression that is experienced when no visible light reaches the eye, in other words, when light is absorbed without being reflected. In vision without sunlight, our perceptual system is less effective, as we only detect variations of light and dark, but are unable to distinguish colours. At night, there is insufficient visual information to define our surroundings, making us more vulnerable. The survival instinct reacts by triggering fear as an alarm in the face of the danger inherent in exceeding one's limits. Fear of the dark therefore plays a fundamental function, as it is an effective tool for protecting and preserving the species.

In the collective imagination, throughout the centuries, darkness

has thus found a place in fear, sleep, and inactivity. And so has blackness. Dressing in black for funerals and when in mourning, for example, is an age-old custom. It dates back at least to the ancient Romans, who wore simple dark-coloured stoles — grey or brown — for funeral rites because the law prevented the use of precious and bright fabrics. But it was the courts of Europe during the Middle Ages and the Renaissance that popularised the use of all black for mourning. First Louis XII King of France, and then Mary Stuart, Queen of Scots executed in 1587, who ordered her ladies to wear black Spanish-style dresses for her wake. The influence of Spanish culture was instrumental in the spread of black. Charles V and Philip II, both fervent Catholic kings, had in fact imposed a very strict dress code to keep in check their courtiers and avoid the excesses of other European courts. Nevertheless, the influence of the Spanish court at that time was such that black defined its identify and became very fashionable.

Nowadays, in design and communication, black is used in terms of two of its basic characteristics. The first is the sense of weight it conveys. Simply put, black objects (or text) give the impression of being heavier than white or light-coloured ones. So, to communicate a sense of texture, an indication of quality in luxury products, design often makes use of black, combining it mainly with gold. The second characteristic concerns its physical nature. Since it does not reflect light, but absorbs its heat, it is a very efficient heat conductor. It is therefore perfect for attracting the sun's rays and transforming them into energy. And solar panels, strictly black, are now a constant feature in the landscape.

EFFECTS OF BLACK IN INTERIOR SPACES

On ceilings it creates an overwhelming sense of emptiness.
On walls it gives an eerie effect.
On floors it is more suitable but tends to make walking more laborious.
Black is at its best as an accent, juxtaposed with other tones that are enhanced by the simultaneous contrast. Excessive use of black in rooms makes it soporific, because the retina, registering the decrease in light, sends signals to the brain, and from there to the central nervous system, that deactivate the waking state.

No one can remain indifferent to colour. Our reaction is immediate, and is both emotional and instinctive. It stems from sensory perception which, as we have seen, triggers a series of physiological and psychological responses. There is much that is personal, of course, but psychology has long shown that there are also universal reactions, independent of people's cultural influences, age, and gender, and that they therefore have an objective character. It is on the basis of these peculiarities that we can study the effects of colours on our organism and develop theories and practices to harness their symbolic power, their ability to influence moods, and thus to make the best use of them as tools of information and communication, but also as levers for our personal well-being and to create comfort in the spaces where we live.

Chapter 3

MY FAVOURITE COLOUR

SOME SIMPLE PSYCHOLOGY WITH A HINT OF PHYSIOLOGY

O f the tools we possess to "switch off" our brain and disconnect it from anxiety, stress and worries, a special place is held by colours, or rather colouring: a true relaxation technique that is increasing in popularity. When we focus on colours, we have to coordinate our eyes and hands. This allows us to activate areas of our brain that inhibit the limbic system, the "sentinel" of our emotions. Through colours, in short, we can unite the logical part of the brain with the creative part by attenuating the intensity with which we focus on our thoughts and anxieties.

Colour psychology is not a marketing invention or an extension of New Age mysticism. It came about because colours are able to stimulate our minds and provoke a great number of emotions. It is based on physiological findings, and aesthetic, psychological, medical, and biological information. Its field is vast, and to fully understand it, we need to realise that colour is not merely a decoration subject to individual taste, but a sensory perception that triggers a chain of psychological and physiological reactions. Among the first to recognise a relationship between personality and colour was the Swiss psychiatrist Hermann Rorschach, who in 1921 developed perhaps the most famous projective psychological test in history, the interpretation of "inkblots". Even today it is used for the diagnosis of neuroses, affective disorders, and the representation of oneself and others in relationships. The test is based on ten cards — five in black and white, two in red and black, three multicoloured — which are shown to subjects who are asked to express their feelings by associating an image with the blot. Some are influenced by the colour, others by the shape. In general, we can say that people with a comfortable relationship with the outside world appreciate colour, while more closed people reject it. Our personal relationship with colour and its meaning can only

be probed using psychodiagnostic tests. These are tests in which judgments about colours that we like, dislike or are indifferent to must be made spontaneously and not gleaned from mental associations with past experiences or objects (e.g. clothing, pieces of furniture, materials). The tests do not refer to the impression that colours make on us. We speak instead of *expression*; an expression that characterises us and gives an indication about ourselves. Projective tests were in fact developed with the aim of analysing or understanding a subject's personality in an indirect, colourful and effective manner. There are tests that serve to diagnose pathologies and tests that merely probe character traits.

REFLECTIONS ON CHARACTER AND MOOD

It was another Swiss, the psychologist Max Lüscher, who noted the universal reactions aroused by the principal colours. In 1947 he invented a test to analyse a person's mood from the colours they choose. After years of testing, he came to the following conclusion: "Colour is an international language that is not linked to any culture. Every colour has its own objective, universal meaning. This chromatic meaning is valid for all cultures and genders, as well as for all ages." And more recent research — comparing men and women, children and adults, experts and amateurs — has shown that the majority of individuals share the same reactions to different colours. Character studies, also with reference to colours, originate well before psychoanalysis and date back to ancient times. For millennia and until the birth of the scientific method at the turn of the 17th century, it was taken for granted that the world consisted of four elements, each symbolised by a

colour: fire, air, water, and earth. Human temperaments were also derived from these elements and colours. Thus, in ancient Greece Hippocrates devised a classification system of the four humours of the human body — blood, yellow bile, black bile, and phelgm — from which come the four human temperaments: choleric, melancholic, sanguine, and phlegmatic. A choleric temperament corresponds to fire and is red; a melancholic temperament to earth and is blue-purple, blue and black; a sanguine temperament to air and is yellow; a phlegmatic temperament to water and is green, green-blue-white. But it was Galen of Pergamon, physician to the Roman emperor Marcus Aurelius, who formulated the classification of the four human temperaments, which was never questioned for some 1,400 years. What makes his work significant is the fact that he also defined colour preferences, the symbolic expression of which is, to a certain extent, still valid today. His classification was as follows: choleric/red, melancholic/blue, sanguine/yellow, phlegmatic/green. And here is the modern chromatic symbolism: red as aggressiveness, activity, strength; blue as sadness, melancholy, depression; yellow as joy, vitality, high spirituality; green as isolation, tranquility, privacy.

Associations between personality and colour have also always recurred in astrology, formerly considered a science, which follows its own colour classification. For example, Aries — impatient and irascible, charismatic and self-confident — is associated with the colour red and the planet Mars, which the ancient Greeks chose to name after the god of war because of its reddish hue. And even though we now know that this colouration is due to the large amount of iron oxide surrounding it, we still accept the original astrological view. Especially since the relationship between the symbolic expression of this colour and the character type with which it is associated is often confirmed by projective colour tests.

But we should not derive any certainties from this and, indeed, we should be aware that in the wake of the success of the New Age phenomenon, numerous pseudoscientific publications on colour have flourished in recent years, turning often questionable deductions and improvised practices into absolute truths.

EMOTIONAL REACTIONS

In 1947, the Swiss psychologist Max Lüscher drew up a list of basic associations and reactions to colours that is still considered reliable today.

Red: impulsiveness and intensity, blood, sexuality, youth, energy.

Brown: receptivity, sensuality, Mother Earth.

Orange: competitiveness, excitability, activity.

Yellow: philosophical detachment, anticipation.

Green: regeneration and growth, hope.

Blue: trust (except for food).

Dark blue: peace, security, contentment.

Purple: magic, fantasy, sentimentality.

AN EXTRAORDINARY MEANS OF COMMUNICATION

Now that psychology has come to permeate almost every aspect of our lives — from dealing with emotional problems, family, work, sport, education to the way supermarkets arrange merchandise — understanding the mental mechanisms of colour is useful in so many fields. In this case we are talking about applied colour psychology, the one most interesting for the purposes of our discourse. Because, as the German psychologist Ulrich Beer wrote, rarely does a phenomenon found in nature contain such a preponderant psychological aspect as colour, so much so that no one can remain indifferent to it: "We are immediately, instinctively, and emotionally moved by colour. We have sympathy and apathy, pleasure or disapproval within us as soon as we perceive colour". In fact, to the two reactions of sympathy (acceptance or approval of a colour) and antipathy (rejection or disapproval) we need to add a third, one that goes beyond the positivity or negativity of the assessment. It is not really a reaction. In fact, it would be more appropriate to describe it as an expectation, perhaps even indifference, in the sense that we immediately show no judgement or emotion because the colour corresponds to what we expect to see when we observe it. In short, we can say that we are programmed to assume that certain physical configurations have a particular colouring. If this is not the case, if the object-colour relationship goes beyond our expectations, then we have to face and evaluate a colour signal for which we are not prepared. An easy example is the chocolate bar: buying a black chocolate bar does not arouse any emotion in us, but if we then discover that it does not contain dark chocolate but milk or even white chocolate, we are bewildered and ultimately disappointed.

So, whereas psychology proposes theories and conducts research with the aim of better understanding our behaviour and mental processes, applied psychology uses these theories and research to address practical problems and everyday behaviour. When it comes to applied colour psychology we are talking about the ability to influence people's moods (and thus their choices). Because through research into its symbolic, associative and synaesthetic effects, colour is transformed into a powerful means of communication, into an element that enhances the message to be conveyed. As the colour psychologist Harald Braem explains, "that colour plays a primary role in visual information is self-evident." Whether it is choosing a car or a dress, shopping or furnishing a house, navigating traffic, leafing through a book or choosing a gift, we are all confronted with the secret power of colour because "colours actually influence and control the complex of thought, feeling and action in a lasting way." On 16 August 2009 Jamaican sprinter Usain Bolt set the world record in the 100-metre dash by running 9.58 seconds in the final of the World Athletics Championships in Berlin. According to Braem, this was also due to the unusual colour of the track, not red but blue, because "it is a fluid colour, which allows the athletes to run in a more stress-free way".

But how are colours chosen to send targeted messages? According to another eminent colour psychologist we have already mentioned, Heinrich Frieling, past experiences can lead to definite associations and "in certain situations, colour can automatically elicit a very specific reaction, without any premeditation." This is evident in the way colours are used in international signage and industrial safety codes. They are choices dictated by psychological motivations. As we know, red creates a state of alarm, yellow a state of alertness, green instils an impression of security, and blue makes us aware and rational. Of course, colours must always be

considered in their context and much depends on their brightness, intensity and the colour combinations used. For example, in the field of advertising Max Lüscher developed a list of colours that he considered to be psychologically effective, the result of decades of investigation using his colour test. So a predilection for yellow denotes a desire for novelty, but when associated with red it signifies conquest and development. It does not, however, take an expert in colour psychology to recognise errors in the presentation of a product; the consumer will spot them intuitively. Selling tranquillisers in a red and orange package, colours that communicate excitement, intensity and activity, would just be absurd.

IT IS ALSO A MATTER OF SHAPE AND SIZE

Our visual perception of the whole is not only based on colour, but also on shapes and lines. In almost all reference literature — from the writings of Johannes Itten to those of Wassily Kandinsky and Heinrich Frieling — for various reasons and on the basis of different considerations, the three primary colours, red, yellow and blue, are associated with three basic shapes, square, triangle and circle.

The square is solid, consistent, static, and goes well with a dull, charged red. The triangle symbolises thought, it reaches upwards, it somehow radiates, just as yellow does, light, shiny and pure. The circle is spirit, fluid movement, relaxation, and finds its expressive counterpart in a balanced, evocative blue. It is rather surprising that in many surveys even subjects who were not familiar with these studies judged the relationships formed by these colours as the most harmonious or appropriate.

Actually, the red square, the yellow triangle and the blue circle date back to ancient times. Geometric symbolism is found in tarot cards, Egyptian mysticism, and even Freemasonry. These forms were later transformed into religious symbols. The square to represent the Earth, as it derived from the Egyptian concept of solidity at the base of the pyramid. Earth and red were synonymous, so red was associated with the square. The triangle to represent hierarchy was associated with yellow because it was a symbol of intelligence. The circle was associated with blue because it was considered holistic, divine, spiritual, and it represented the celestial vault. All other colours and shapes are derived from these three primary colours and shapes. Johannes Itten went even further and in his book, *Art of Colour,* he wrote: "If we look for shapes to associate with secondary colours, we find a trapezium for orange, a spherical triangle for green, and an ellipse for violet."

The correspondence between colour and shape depends on the hue, intensity, and brightness. For example, the red associated with the square must be stable, heavy; a vibrant, brighter red may not tend towards the solidity and static nature of the square; a dark, charged blue might appear as solid as the red within the square. In general, the correspondence between shape and colour can increase the expressive power of the message by eliciting associations of mood. In many cases, these principles may be subject to variation, for example when aiming for a particular message or impression by comparing colour with the essence of various shapes. According to Frieling, in fact, red in a triangle might appear more vibrant as it adopts the traits of the radiating yellow, whereas a blue triangle could express a surprising movement and brashness. And again, according to the German psychologist, familiar shapes associated with "unexpected" colours can enhance our emotional reaction. He demonstrated this with a test based on a comparison

of two schematic images, identical in shape but opposite in colour. Both images depicted a mountain (triangle), a round sun in the upper-left corner, and an oval lake-like horizontal area at the base of the mountain. The participants had no particular reaction to context "a" with classic colours: the yellow sun, the lighter blue sky on the horizon, the purple mountain, and the deep blue lake. While context "b" — blue-violet sun, darker red-orange sky on the horizon, light yellow mountain, pure red lake — elicited spontaneous emotional comments such as: the lake is a burning desert, a lake of blood, frightening, mysterious.

A NOTE ON THE PHYSIOLOGY OF COLOUR

Colours do not exist. A bold statement, but it is true. Colours are the mental representation of electromagnetic waves. They are the result of perception, the process of recognising and interpreting stimuli from the surrounding environment recorded by our senses. As physicist and science populariser Andrea Frova explains, "The great privilege of seeing colours is reserved for humans and certain species of animals, such as birds, reptiles, fish, and insects." The vast majority of mammals, including monkeys, have rudimentary or no colour vision at all.

Sight, the richest of our senses, provides us with a wealth of information that we would not be able to receive without light, the fundamental stimulus of sight. Of the entire field of electromagnetic radiation, the human eye is able to see only the central part, the one with a wavelength between 380 and 780 nanometres, which is why it is known as the visible spectrum. It is the part that constitutes light and, chromatically, ranges from red to vio-

let. In between we find orange, yellow, green, blue, and indigo, as well as a huge range of intermediate colours. In all, we are able to distinguish over ten million different shades. The other waves of the electromagnetic spectrum are not perceived by our sight, but that does not mean they have no effect on us. But while longer-length waves, such as infrared and radio waves, have low intensity and are harmless to living organisms, shorter-length waves, such as ultraviolet and gamma rays, have high energy and cause biological damage.

The mechanism of colour perception is very complex. Our senses perceive stimuli from our surroundings and the nervous system transmits this information to the brain, where it is processed. This process involves both the sympathetic and parasympathetic nervous systems, and consequently our hormonal activity. In fact, the brain processes colours even when we are asleep and not subject to any external bioelectrical stimuli. But let's see how it works in detail.

The eye transforms photochemical reactions triggered by light radiation on the retina into bioelectrical impulses. These stimuli reach the brain via the optic nerve and the information transmitted is processed in various areas of the brain to generate an image. The electromagnetic waves of the visible spectrum that reach our eyes are focused by the cornea. The pupil regulates the passage of light by shrinking or dilating depending on the intensity. The crystalline lens adapts its curvature depending on the distance of the object, causing light rays to converge on the retina. And it is here that the "miracle" of colour takes place. The retina is in fact covered with millions of photoreceptors, light-sensitive cells that transform visual stimuli into electrical impulses and send them to the brain via the optic nerve. There are of two types of cells: cones and rods. The rods that cover the peripheral areas

of the retina enable vision in very low light, but have poor colour sensitivity and act mainly in night vision. The cones, which are concentrated in the central area of the retina, require a high level of illumination and, in the presence of a suitable light source, generate chromatic vision.

THE INTERACTION BETWEEN OUR BODIES AND COLOURS

But why does every colour cause certain physiological reactions in our organism? Because different demands are made by each colour on our sight: the greater its wavelength, the more demanding the process of adaptation required for its visualisation. For example, to focus on red our perceptual apparatus must adapt to its wavelength which is the longest of all the colours. Its light radiation, before converging on the retina, passes through the lens and shifts the focal point of the eye forward. The ensuing adaptation process requires our organism to expend additional energy which, by activating the orthosympathetic nervous system, causes a slight increase in heart rate, blood pressure and respiration. In contrast to red, our physiological reaction to the wavelength of blue, which is shorter than that of red, results in lower energy consumption. Indeed, on a perceptual level, the blue range (together with the green range) is optimal because it converges directly on the retina and so does not require any adaptive effort, and, by also activating the parasympathetic nervous system, respiration, heart rate, and blood pressure actually tend to slow down.

The eye represents the channel through which we interact with the stimulating effect of light. The neural pathway that carries the light stimulus to the pituitary gland is referred to as the energeti-

cal element of the visual pathway. Then the hypothalamus sends signals to the nervous system telling it to react to the changes registered and cause the production of hormones. This process can be considered as the transposition into the animal world of the fundamental principles of chlorophyll photosynthesis. Recent studies have conclusively shown that natural light has profound effects on the human organism and impacts our health. Generally speaking, light stimulates the activity of the endocrine glands by promoting the release of hormones that regulate our vital functions. In particular, the pineal gland, which secretes the melatonin hormone that regulates our sleep-wake rhythm, is very sensitive to light stimuli. Light also triggers the circadian rhythm, or our biological clock, a system of cyclical variations that affect our body's activities every day. The name comes from the Latin *circa diem*, meaning "around the day", and describes a complex system of changes in blood pressure, body temperature, muscle tone, metabolic activity, heart rate, sleep-wake rhythm, and much more. Finally, our mood, our physical and psychological endurance, our cognitive performance, and our behaviour also depend on light.

An environment with well-matched colours is harmonious and supports the actions we perform within it. The decisive influence of colours on our behaviour, also on an emotional and physical level, should keep us away from the idea that "colouring" a space is simply a matter of aesthetics, perhaps driven by the fashion trend of the moment. When preparing a design we should instead consider many factors, such as shape, size, and function. A skilful and conscious use of colour is based on certain ergonomic principles, a few basic rules, and the knowledge that the goal is to achieve a balance of colours. A balance that is necessarily dynamic, because it also takes into account variations in light, whether natural or artificial, that alter the perception of colours. Never forgetting to leave room for inspiration and imagination.

Chapter 4

THE
SIX GOLDEN
RULES

ESSENTIAL PRINCIPLES OF COLOUR
DESIGN AND ERGONOMICS

J ust as in meteorology we give fundamental importance to climate, to the complex of atmospheric conditions that characterise a place or a region during the course of the year, so we should do the same when it comes to colours. There is in fact also a *colour climate*, which is the set of relationships established between the attributes of colour (its hue, brightness and saturation level), light and every visible element present. It is a crucial factor, because a favourable colour climate makes a room harmonious, aids our perception of space, enhances our sense of orientation, and consequently facilitates all the actions we perform daily within it.

But how do you construct a favourable colour climate? First of all learn something about ergonomics, the scientific discipline that enables us to work at our best, to find solutions adapted to our abilities and psychophysical limitations. In fact, the theories and techniques of ergonomics are now applied to every environment we live in, not just the workplace, and colour is considered a key element to take into account. The first concept to become familiar with is *chromatic adaptation*, the ability of the human visual mechanism to adapt in response to the average chromaticity of the stimulus. Simply put, this is what happens when we put on a pair of sunglasses; initially everything appears to be the colour of the lenses, but after a few moments we get used to it and no longer perceive their shade. When we are overstimulated, in other words when we are exposed to an excess of stimuli within a particular space, we register changes in breathing rate, pulse rate, and blood pressure. And polychromatic environments, if the colours are not balanced, are overstimulating. If, on the other hand, we speak of hypostimulation, when we are exposed to a kind of sensory deprivation within an environment, we show signs of restlessness, exaggerated emotional reactions, and lack of attention. This is

exactly what happens in monochrome spaces. Colours play a very important role in the functioning of our vision because they can guarantee both efficiency and comfort; and as we have seen, they can never ignore light. The process of adaptation of the eyes to an environment primarily involves immediate reactions to changes in illumination. A low refractive index of light causes the pupil to dilate, while a high refractive index has the opposite effect.

However, colour is often mistakenly identified as a mere decorative element, without considering its fundamental influence on human behaviour at both the conscious and unconscious level. When it comes to "colouring", we cannot therefore limit ourselves to purely aesthetic issues and superficial judgements based on personal taste or, even worse, fashion trends. Colours, as we have seen, are perceived by our brain which then processes and evaluates the information received both objectively and subjectively. And so colour stimuli have a profound effect on our inner selves. All the more so since our reaction to colour depends, not only on external agents, but also on our capacity for imagination. Imagination, in fact, is indispensable for the impression of a certain colour to provoke precise physiological reactions and also activate a cognitive process.

For design purposes, the culture of colour is a valuable resource because it can improve the environment as well as enrich people, bringing concrete benefits to our quality of life, rendering everyday actions and relationships more pleasant. Narciso Silvestrini, a great scholar of colour and projective geometry, throughout his many years of teaching has always introduced his students, and future professionals, to a basic principle of good design. Referring to optical physics and the distinction between first-degree, radiating sources, like the sun, and second-degree, reflecting sources, like the moon, Silvestrini always explained that "objects and their

colour must also be considered as cultural perceptual sources of energy. Designing and applying colour means stimulating energy, it means designing sources of energy."

CONTRAST AND HARMONY

The presence of several colours, polychromy, should be thought of as a system of relationships between the colours, not as a set of random combinations. And we can go so far as to say that polychromy is a bit like freedom: finding a balance is worth fighting for. Since a monochrome environment is undesirable, knowing the possibilities of colour matching helps us achieve a desirable colour climate. The relationship between colours is one of contrast and harmony. The stronger the contrast, the more we struggle, because we have to constantly adapt our vision. Rather, the eye should be helped when experiencing colour by considering certain basic aspects and the rules of contrast.

In general, when observing a space, we tend to identify three levels of colour: the *dominant* colour, the one that stands out most; the *subdominant*, which comes next in terms of physical extension; and the *accent*, which is represented by colours that, albeit in small quantities, capture our attention. The harmony of this whole can come from a skilful use of colour contrast. This issue should not be underestimated because, as we have seen, colour triggers physiological reactions. And contrast is no exception. Just think of what is technically referred to as *after-contrast*, an astonishing phenomenon: our brain can decode the information transmitted by the eye stimulated by the vision of certain shapes and colours, producing what is called an *after-image* that is entirely non-existent in reality. This phenomenon occurs after staring for only a

few seconds at a single colour or a sequence of tones, and then shifting your gaze to a white background. With a single colour, its opposite (complementary or polar) appears before our eyes, while a sequence of tones is reversed. The intensity of the after-image varies depending on the length of time the actual image, the real one, was imprinted on the retina. It may sound like a game, but it's not; in operating theatres surgeons, to compensate for the blood red stains they see, wear blue-green gowns in blue-green rooms, the exact opposite of red, to avoid the consequences of this phenomenon and re-establish normal vision.

Then comes *chromatic contrast*, the ratio, or difference, between the higher, brighter value and the lower, darker value. Changing the contrast, increasing or reducing it, helps to harmonise and match the colours. Not just one type of contrast exists. It can be *tonal*, two contrasting colours that are adjacent (side by side in the colour circle), complementary (a primary and a secondary at opposite ends of the colour circle), or polar (opposite tertiaries in the colour circle). *Saturation* is instead achieved by placing a saturated colour alongside a less saturated or neutral one, for example, red alongside pink, or bright, intense colours alongside opaque or dark ones. *Chiaroscuro* is also a contrast, in this case between a light colour and a decidedly darker one, as in classic black and white. The contrast of *hot and cold* is obviously obtained by the combination of warm and cold colours that can be complementary or polar within the colour circle. The contrast of *quality* is created between intense colours and duller ones. The perceived sensation is very intense; just imagine how much a red dot of any size placed in the centre of a blue background attracts the observer's attention. The contrast of *quantity* is then the consequence of the dimensional relationship between two or more colours, a relationship that should never be underestimated. Let's take the easy example of a man dressed in

yellow and blue, and imagine how he would look in a blue suit combined with a yellow tie, and, conversely, how he would look in a yellow suit and blue tie. Here, a less bright colour needs to cover a larger area to contrast a brighter one. In a balanced ratio, blue should occupy almost three times as much space as yellow. The contrast of *surface* depends on glossiness or opacity, properties that significantly alter our perception. Colours appear more vivid and bright on a glossy surface, more saturated on a matt surface.

Finally, *simultaneous* contrast is another "magic trick" of our perceptual system involving the eye's ability to perceive differences in colour nuances through the decisive influence of surrounding colours. For example, orange placed on a red background appears closer to the yellow range, whereas if placed on a yellow background it appears to belong to the red range. Simultaneous contrast has several effects. It affects size, so that a light-coloured element on a dark background appears larger than a dark element on a light background. It affects brightness and makes the same colour appear darker on a light background and lighter on a dark background. And it also affects saturation, which is enhanced if the background is less saturated and vice versa. Finally, it significantly varies the tone. A coloured background brings out the component closest to its complementary or polar value. For example, purple on a green background looks more red, but orange looks more blue.

In conclusion, we can say that chromatic contrasts are based on the principle of similarity or of opposition. Similarity generates contrasts that are not excessively strong, whereas opposition brings together discordant elements. Within an environment, and depending on the peculiarities of the space, colours and contrasts can have a *consonant* effect when they enhance certain characteristics, or a *compensating* one when they help to mitigate negative

factors. For example, in a very noisy environment, green has a compensating effect, whereas orange has a consonant effect. And, as you can guess, in a noisy space a consonant effect is counterproductive. In an environment full of unpleasant odours, however, it is the lilac and wisteria range that has a compensating effect. But placing warm-coloured woodwork in a room with a fireplace generates a consonant effect. That is why design must always be related to the function to be performed in a certain location and its duration. Without ever forgetting the fundamental issue of exposure to natural light.

THE BEHAVIOUR OF LIGHT

In order to draw some useful conclusions when choosing colours for your home, it is important to bear in mind that how we experience colour depends on the intensity of the light, the way it is reflected from a surface, and the coloured objects present. To create a pleasant ambience, a careful control of colour is as important as that of brightness. In short, this means one of two things: either colour is adapted to the existing light in a given environment, or colour and light are planned simultaneously. Depending on the particular distribution of visible natural light, colour also undergoes changes, and there are types of light that enhance certain colours more than others. And also consider that the colour of the light itself, which can be warm (with an orange reflection) or cold (with a bluish reflection), also exerts an influence.

In this regard, it is worth mentioning the observations made by the Dutch physicist Arie Andries Kruithof who, by means of a curve, managed to describe a region where the levels of *illuminance* and colour temperature feel comfortable, or at least agreeable, to an

observer. To be clear, illuminance is a physical quantity that does not refer to the light source, but to its behaviour when it strikes a surface. It reaches its maximum when the surface is perpendicular to the light rays, and its zero when it is parallel. It is measured in lux. Colour temperature, on the other hand, refers to the hue of the light. This value is expressed in degrees Kelvin (K) on a scale of 1,000 to 12,000. The higher the Kelvin number, the whiter or bluer the light will appear. In short, Kruithof found that a colour with a low temperature is preferred when the light is intense and a colour with a higher temperature when the illumination is low. And he also noticed that the colours of objects and surfaces appear "normal" under low intensity warm light or under high intensity cold light. In terms of reference values, natural daylight has a colour temperature of 6,500 K and an illuminance of 10^4 to 10^5 lux. Under these conditions, a natural colour rendition is produced, which just happens to be the one that Kruithof's measurements found to be the most pleasing. And in fact its curve contains colour temperatures and illuminance levels comparable to environments with *natural light.*

In addition, a key role when it comes to light and colour is played by surfaces: floors, walls, ceilings, furniture, objects. Their colours absorb and reflect a certain amount of light which determines the *refractive index*. In the visual field, what reaches the eye when light is reflected from a surface is not the intensity of illumination but the light density. In practice, what strikes us is the reflection of light incident on different surfaces, which varies according to colour, but also the glossiness or opacity of the materials, so whether they are reflective, absorbent, or transparent. Excessive differences in density force the iris to adjust continually and this causes eye strain. This is why regulations provide precise rules and parameters to be followed in order to design spaces correctly.

Frank H. Mahnke, a great colour expert and author of one of the reference texts in the field — *Color, Environment, and Human Response* (1996) — explained that the integration of humans and architectural space creates favourable environmental conditions for living and working only in chromatically balanced contexts. His idea of design is based on people's individual wellbeing and dignity because the relationship between body, mind and soul is physical, intellectual and emotional; and because individuals constantly interact with the world around them, which stimulates the reaction of the psyche. But how can we meet people's needs and improve the liveability of an environment if every individual is different and reacts in their own way psychologically? In fact, as we have seen, many psychological and physiological reactions to colour are common to most human beings. And in any case, good design implies that the combination of colour and light gives rise to a moderate stimulation of the senses. The aim is balance and harmony, not stress and shock.

THE REFRACTIVE INDEX OF LIGHT

Regulations require that any space should have a light refraction ratio of three to one.

Floors: a refraction of about 20%.

Furniture: from 25 to 40%.

Walls: from 40 to 60%.

In practice, the lightest colour (60%) divided by the darkest (20%) gives a ratio of 3:1.

The light refraction index of *ceilings* must always be between 80 and 90%. Interestingly, if the designers applied these rules correctly, there would be no white rooms, because the refractive index of this colour is 90% and so it would be usable (but not recommended) only for ceilings.

THE BASICS OF
COLOUR DESIGN

Good designers know they cannot limit themselves to their own point of view. They are aware that they must not impose their own taste and should, instead, consider the human reaction to colour. But as Alessandro Mendini, an architect and designer who used colour in a most sensitive and original way, was eager to explain: "A design is composed of various languages in rhythm with each other: shapes, volumes, decorations, materials, and colours. They all contribute to the reading of the object, like visual alphabets." But when asked about his colour preferences and their influence on his design choices, he asserted his professional independence and revealed that he loved pink. "Maybe my favourite colour," he said. And, above all, he admitted to the subtle pleasure of transgressing the rules of ergonomics in favour of a natural instinct towards certain colours and combinations. To the point of making it a design method: "A rule I apply is to combine colours with a degree of disharmony as they tend to attract more attention. Despite the prevalent use of certain palettes, colours are reinvented every time."

But in the absence of Alessandro Mendini's talent, if the aim is a good result rather than an aesthetic exercise, it is first necessary to carry out a detailed analysis of the spaces and establish the sensations they arouse. Our perception is in fact based on continual adaptation to the visual conditions of an environment. The right colour balance implies that all the elements present are in harmony, resulting in a whole in which each colour is consistent with its context. In environments where no harmonious relationships are established between the various elements, there is an excessive visual complexity that requires a constant effort of adaptation.

This may not seem so important, but in actual fact it constitutes an unnecessary waste of vital energy. A chromatically balanced environment, on the other hand, positively affects our psychophysical well-being. It reduces fatigue and combats stress, and inhibits irritability. Above all, it enhances our sense of orientation, thereby also increasing the safety of the location. So here are the six golden rules of colour design:

1. *Carefully analyse how environments are displayed* and always consider the variations in natural light over the course of the day and the cycle of the seasons.
 Colours must reflect the right balance between shades and varying degrees of temperature.

2. *Create a harmonious colour climate within the environment.* Which will be more balanced if the colour of the floor (which supports us) is darker than that of the walls (which confine us). The horizontal plane of the ceiling should always be very bright, but preferably not optical white.

3. *Consider the functions and dimensions of spaces.* The same colour combination produces different effects in different environments with different uses. The time spent in the environment also matters to a great extent, just as temperature and noise influence the effectiveness of the colour context.

4. *Avoid colours that are too dark*, not just because they absorb light and increase electricity consumption, but also because the overall colour climate would be heavy and hypostimulating. On the other hand, light and bright tones create an atmosphere appropriate for any time of the day.

5. *Avoid contrasts that are too sharp.* Hyperstimulating environments have detrimental effects on concentration. Therefore, it is best to avoid strong contrasts of shade, brightness,

saturation. In this way, each colour is uniquely identified with an abbreviation based on three numerical parameters. For example 10R6/4 identifies a red (R = red) slightly shifting towards yellow, with a value of 6, and a chroma of 4.

NCS (NATURAL COLOUR SYSTEM)

Developed and produced by the Scandinavian Institute of Colour, this is the result of over fifty years' work and has its roots in the ideas of Leonardo Da Vinci. The NCS colour system is based on describing colour in terms of how humans perceive it. So it renders an exact definition of the colour we see and encodes the millions of colours that the human eye can theoretically distinguish. At its basis are six "elementary colours", of which four are chromatic (yellow, red, blue, and green) and two are achromatic (white and black). NCS colours are defined by a letter and three values expressed in percentages that specify the degree of darkness, chromaticity, and hue. Take for example colour S 3020-G30Y. The first letter, S, indicates the edition of the system (in this case the current one). The first pair of numbers identifies the colour gradation (30% black and 20% colour, so the remaining 50% is white and the colour is light). The last four figures represent the hue expressed in English (Yellow, Red, Blue, or Green). In this case 30% yellow (Y) and, therefore, 70% green (G).

RAL

Today this is a European matching system for the definition of colours used in paints, coatings, and plastics, but it originally

stood for *Reichs-Ausschuß für Lieferbedingungen* (Committee of the German Reich for Terms and Conditions of Sale, established in Germany in 1925 by the government of the Weimar Republic). It is divided into four different ranges: RAL Classic, introduced in 1927, is continually evolving and includes 213 different colours also identified by supplementary names to avoid confusion when using numbers alone; RAL Design, introduced in 1993 to meet the needs of design professionals, includes 1,625 colours that do not intersect with the Classic range; RAL Effect, 420 solid colours and seventy metallic colours based on water-based paint systems; and RAL Plastics, the colour standard for the plastics industry. RAL Plastics P1 contains the one hundred favorite RAL Classic colours. RAL Plastics P2 contains 200 RAL Design colours. The RAL classification consists of four numbers, the first of which identifies the main colour gradation: 1 yellow, 2 orange, 3 red, 4 violet, 5 blue, 6 green, 7 grey, 8 brown, and 9 white/black. But the RAL Design range, the largest, is uniquely identified by seven-digit codes. Each code indicates the hue, brightness, and chromaticity values of a certain tint.

For example, RAL 210 60 30 is a colour with a hue of 210, a brightness of 60, and a chromaticity of 30. The same lighter hue corresponds to RAL 210 70 30 which, having the same hue and chromaticity values, has a higher brightness.

PANTONE

One of the best-known colour scales in the printing and textile industries, named after the American company that patented it in 1963. Each colour corresponds to a code, adopted internationally, which guarantees a faithful reproduction in print, even on dif-

ferent media, thereby avoiding any misunderstandings resulting from, for example, context, digital visualisation, or the subjective perception of hues.

The Pantone scale is the intellectual property of Pantone Inc. and free use is not permitted. A new guide is produced every year because old guides deteriorate over time and colours fade, and there can be colour variations within the same code. Guaranteeing consistent colour reproduction, the Pantone scale is the system of reference for the printing of national flag colours. The Italian tricolour, for example, is identified by codes 17-6153tc (fern green), 11-0601tc (bright white), and 18-1662tc (bright red). The colour tones of the flag of the Italian Republic, as set out in Article 12 of the Constitution, are defined by the circular of the Presidency of the Council of Ministers of 2 June 2004 using Pantone textile codes used on polyester stamina, and by the Prime Ministerial Decree of 14 April 2006 "General provisions for ceremonies and precedence in public office".

We spend most of our time indoors and almost never in sunlit environments. We are therefore constantly exposed to artificial light, which is quite different from that of the solar spectrum. It is not as complete and, above all, does not change with the passing of hours and seasons. At most we can adjust its quantity, never its quality. Yet our body works on the basis of alternating light and dark, night and day, using our 24-hour biological clock. In addition, our eyes and their ability to function at their best also depend directly on the quantity and quality of light. As are colours, the perception of which is closely related to light radiation. A beam of light has the power to make us see colours, as well as to alter or hide them.

say that the missing wavelengths in any kind of artificial lighting leave our bodies, so to speak, "malnourished".

THE 24-HOUR BIOLOGICAL CLOCK

As we have seen, we humans have a biological clock that coordinates our bodily functions in a circadian rhythm according to the cycle of sunlight over 24 hours. And it sets us up to start the day. Before daylight, and before waking up, there is an increase in our heart rate, blood pressure, and body temperature. This is because around five or six o'clock in the morning our organism kicks into gear.

From a biological and evolutionary point of view, we are and remain a diurnal species. We are active during the day and need to rest at night. Chronobiology, a science that studies cyclical phenomena in living organisms and their adaptation to solar and lunar rhythms, has discovered a vast number of phenomena related to the functioning of our internal clock. At eight o'clock in the morning, for example, most of the hormones associated with sexual activity start circulating in the blood. An hour later, we have maximum strength in our hands, whereas between ten o'clock and midday it is the brain that reaches its peak performance. Around one o'clock, whether we eat or not, the maximum amount of gastric acids are produced. Taste, smell, and hearing are most acute in late afternoon, but the liver is most active between six and eight o'clock in the morning. The same time as the skin is particularly receptive to the active ingredients in cosmetics. Circadian rhythms also punctuate our activities throughout the day: between ten o'clock and midday our short-term memory is at its

most efficient; useful for students at school, and to concentrate at work. In the evening, between six o'clock and midnight, when long-term memory is most acute, devote yourself to study.

THE PREVALENCE OF ARTIFICIAL LIGHTING

The human body has adapted to artificial electric lighting for about two centuries. In terms of its colour temperature, the spectrum of incandescent lamps (which no longer comply with current energy-saving regulations) is not very different from that of natural light. The low colour temperature produces a warm light highly reminiscent of fire or a candle. This is why incandescent light sources do not significantly alter the shift from sunlight during the day to fire — or warm light — during the night, as we have experienced for millennia. And some effects of adapting to this type of light source are evident, especially from a psychological point of view, precisely because warm light is usually associated with the idea of relaxation.

Fluorescent light, introduced in the late 1940s, and the more recent LED technology, are potentially much more biologically significant. Because, although the spectral composition of fluorescent and LED lighting differs greatly from that of sunlight, these sources are now also used during daytime to replace natural light, above all in the working environment.

But since the ability of our eyes to function at an optimal level is directly related to light, when illuminating a space the emphasis must rest upon achieving comfortable visual conditions. We often think that eyestrain is concentrated in the optic nerve or retina. But this is not the case. The retina is highly resistant to fatigue

and can withstand strain. As do the nerves. In fact, it is the eye muscles that are most vulnerable. Like any muscle subjected to excessive activity, eye muscles are subject to strain. Dazzling light, constant adaptation to strong changes in brightness, prolonged immobility of the eyes, and continuous straining will quickly fatigue the eyes, causing headaches, tension, nausea, and other common complaints. Research by Étienne Grandjean, a physician at the Institute of Industrial Hygiene and Occupational Physiology in Zurich, has shown that proper control of light contrasts in work environments can considerably increase production and decrease fatigue.

But what is more, artificial light, which is excellent from an optical point of view, must be approached with particular care from a physiological standpoint. Sufficient light and adherence to the basic principles of visual ergonomics are not enough to achieve effective lighting. It is the spectrum of artificial light that we have to worry about. Today, there are lamps that reproduce the natural spectrum of daylight. They have long been tested in submarines and spacecraft to elicit similar physiological reactions to the sun's rays But they are also perfect for illuminating rooms because of their outstanding colour rendering.

Alternatively, there are lamps with a high *colour rendering index* (CRI). They have a much higher colour quality than ordinary cold-white lamps. The CRI index was developed to describe how accurately colours are rendered by artificial light sources compared to natural light. Based on specific studies, lighting experts recommend sources with a minimum value of 85 CRI.

Any light source can leave a cold imprint on the colour if the *correlated colour temperature* — as it is called when referring to artificial light — is high, and a warm imprint if the temperature is low. The colour rendering index, therefore, should never be used without

reference to the correlated colour temperature. Since the value of the colour rendering index of external natural light is 100, the higher the rendering index of a lamp (also taking into account the colour of the light source itself), the more the colours of a space are rendered as "true". Full spectrum light sources, for example, have a rendering index of over 90. It is 68 for cold white and 56 for warm white. Other types of lamps are below 50.

In conclusion, we can say that the problem of how much light is required for the eye to see clearly and easily is a subject for the lighting engineer. But what is useful to know is that too little light impedes good vision, just as too much results in blindness. And that cold light improves concentration, whereas warm light promotes relaxation.

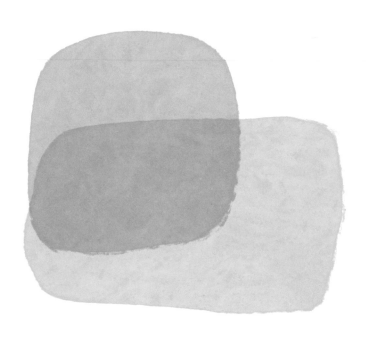

Since the accidental discovery of carbon black in the Palaeolithic era, the history of colour has been a fascinating tale of human obstinacy in the face of wanting to capture the essence of light and reproduce it. The artisans of ancient Egypt, the Phoenician merchants, the Arab alchemists, the masters and apprentices of the Renaissance workshops were protagonists on a par with artists in the laborious appropriation of the secrets of colour. Up until the beginning of the 19th century, when the Industrial Revolution met chemistry and created a new science of colour, with an unprecedented variety of colours accessible to all, it accompanied the rise of the bourgeoisie and the birth of modern taste. A steady growth that in the 20th century was marked by the artistic and cultural avant-garde, two world wars, reconstruction and economic boom, leading to minimalism and the renunciation of colour right at the threshold of the third millennium.

A BIT
OF
HISTORY

THE EVOLUTION OF COLOUR THROUGH THE AGES, ITS USES, CUSTOMS, ART AND ARCHITECTURE

Harvard University boasts the most incredible collection of pigments in the world. It was built by historian Edward W. Forbes, who was also the director of the Fogg Art Museum, one of the university's in-house art galleries. Between 1910 and 1944, Forbes catalogued thousands of samples collected on his expeditions around the world, with one goal in mind: to determine the authenticity of a work of art by comparing pigments. Among the more than 2,700 samples preserved today at the Straus Center for Conservation and Technical Studies at the Harvard Museum of Art in Cambridge, Massachusetts, there are also more recent ones and those donated by experts and artists from around the world. But at the heart of the collection is evidence of humanity's painstaking quest to unravel the mystery of colours. Among all the rarities and oddities, ultramarine stands out, the blue made from powdered zurite from Afghanistan — hence its name referring to its origins in the lands beyond the sea — which costs more than gold and was used in the Middle Ages to paint the Virgin Mary's cloak. But there is also mummy brown, which is by no means rare and was produced in substantial amounts in the 18th and 19th centuries. It was prepared from the resinous extracts accumulated in the bandages of Egyptian mummies. Also deserving of mention is Indian yellow, which has been produced in rural India since the 16th century from the urine of cows fed only on mango leaves and water. There is no shortage of poisons in the Harvard jars, in particular cadmium yellow, introduced in the mid-19th century and much loved by the Impressionists, though made from cadmium, a highly toxic heavy metal. As is emerald green, the green used by Vincent Van Gogh, made from acetoarsenite, a crystalline powder later used as an insecticide.

DISCOVERING THE ART
OF CREATING COLOURS

The history of colour is above all the history of pigments, of humanity's persistent attempt to capture the essence of colour and reproduce it. Endeavours lost in the mists of time, probably dating back to the conquest of fire around one million years ago, when primitive humans first came into contact with the blackness of coal. Thanks to the discovery of tools for grinding pigments, we know with certainty that three hundred thousand years ago our ancestors used to pound haematite, a mineral consisting of iron oxide, which when crushed took on a red colour that they used to paint their bodies, and then to draw lines and figures in caves. In the Palaeolithic period, they painted with what they had at their disposal; as well as haematite for red and charcoal for black, they used chalk and ground bone for white, and made yellow from ochre, another mineral form of iron oxide.

Making and procuring colours was not a simple matter in antiquity. The substances used to dye cloth, create works of art, or decorate architecture could be of plant, animal, or mineral origin. But getting hold of them required ingenuity, treacherous journeys, and considerable expense. Take red, for example. Purple is one of the oldest pigments and the fortune of the Phoenicians was built on it at least until the second millennium BC, and, in fact, their name comes from the ancient Greek *phoínix* meaning purple. The Phoenicians based much of their trade on this pigment and derived enormous wealth from it. They manufactured it by extraction from murex snails which were abundant at the time in Mediterranean waters. This gastropod mollusc secretes fluids that, when exposed to air and light, take on a red colour with more or less blue shades, depending on the species. On the opposite side

of the ancient world, in Central America, another kind of red was all the rage. Introduced by the Aztecs as a dye and pigment for painting, it was later brought to Europe by the conquistadors in the 16th century. This was cochineal red, also of animal origin, derived from a family of insects related to ladybirds, or scale insects. The pigment is produced by the females which secrete a very thick, coloured liquid known as carminic acid, used to coat themselves as a protection against predators. The highest concentrations are found in pregnant females, whose bodies are dried and minced. And it takes about one hundred thousand of them to produce one kilo of dye.

However, it was alchemy that revolutionised the pigment industry. The forerunner of modern chemistry, its imaginative theories and esoteric practices have helped to accumulate a vast amount of surprising empirical knowledge. The alchemical preparations of the Egyptians are well known. For example, they produced white lead, a lead carbonate obtained by macerating strips of the metal mixed with manure and vinegar in earthenware jars. It was then fired in furnaces which at a moderate temperature formed litharge, a yellow lead oxide, and at higher temperatures produced minium, another lead oxide but which was red in colour. They also created one of the most ancient blues, Egyptian blue (or blue frit), obtained by mixing quartz or siliceous sand with carbonates of calcium and copper. The mixture was ground, mixed with water and finally triple-baked in a furnace for up to one hundred hours. A few centuries later Arab alchemists synthesised mercury and sulphur to obtain mercury sulphide, an intense and brilliant vermillion red used from the 11th century onwards to illuminate manuscripts.

But it was the apprentices in the workshops of Renaissance artists who launched a small revolution. Their job was to grind up

minerals to obtain very fine powders. This was a crucial to the final colour rendering, the hue of which depended precisely on the fineness of the powder obtained. Today we also know why. Even in those early types of mortar and using only "elbow grease" they could obtain particles with a diameter of about half a micron, that is, 0.5 thousandths of a millimetre, a measure comparable to the wavelength of visible light with which they could then interfere. Today we would call it nanotechnology; at the time it was a sign of superior craftsmanship. In the same period, new artificial colours appeared in the workshops of Venetian painters due to the development of glassware on the islands of the lagoon. Smalt, for example, was obtained by crushing and grinding coloured glass with cobalt compounds. Titian also used it along with the older azurite blue and lapis lazuli.

THE INDUSTRIAL REVOLUTION AND THE TRIUMPH OF CHEMISTRY

Up until 1856, when William Henry Perkin prepared and marketed mauveine, no significant events occurred in the field of pigments. Prussian blue was introduced at the end of the 1600s, and a century later, new pigments appeared to replace the highly poisonous lead-based ones. But most of the work was concentrated on the search for synthetic inorganic pigments that were purer than natural ones. Lucky accidental discoveries were also made, such as the ultramarine blue that formed spontaneously in lime kilns and could be used instead of the original and highly precious lapis lazuli. But why is mauveine so important? Because it was the first artificial dye to be synthesised. Perkin discovered

this by chance during a home experiment while still a college student. He was trying to synthesise quinine, an expensive drug used to treat malaria, but the chemical reaction failed. He obtained a black substance that he diluted with methanol, perhaps to wash it away. What he saw, however, was a solution of a beautiful purple color that he tried to use to dye a piece of fabric. The result was excellent, a beautiful shade, bright and resistant to light. Of course, he had no idea that his discovery would revolutionise the chemical industry, but he decided to give the dye a name anyway. He first christened it Tyrian purple, after the ancient purple, and then aniline purple, after the reagent used. In the end he chose *mauve* (the French name for the mallow flower), or mauveine. He patented it in 1857, opened his first factory in north London and proved to the world that producing new colours required investment in research.

And so we arrive at the culmination of the history of colours, at the transition from the 18th to the 19th century that brought us to modernity. At that time, the Industrial Revolution combined with the development of chemistry and gave rise to the new science of colour. The theories formulated by philosophers and scientists aroused the interest of numerous painters, influencing artistic movements and especially the nascent applied arts. Creating a real stir was Johann W. Goethe, whom we all know as a great poet, writer and playwright, but who was also a talented painter who went on to investigate colours. In 1810, about a century after the publication of Newton's *Optics* (1704), Goethe published in Tübingen *Zur Farbenlehre*, his theory of colour. And, as they say, nothing was ever the same again. His work was entirely original in structure. While formally clashing with Newton's theories of optical physics, the text took a multidisciplinary approach and included sections on the physiology of perception,

and the aesthetics, psychology, and even the moral aspects of colour. The controversy with Newton related to the mechanistic and atomistic concepts of the English scientist. What Goethe contested was Newton's claim of imposing mathematical processes on colour thereby limiting himself to purely quantitative measurements. Whereas Goethe, who considered colour to be the result of the interaction between light and darkness, was convinced that a science of the chromatic world and vision should also explain and include subjective, qualitative, aesthetic, and spiritual data. Goethe's work captured the cultured European aristocracy, sparked heated debates between Newtonians and Goethians, but above all was a fundamental stimulus for the development of philosophical thinking on colour and new fields of science, such as colorimetry.

The other fundamental theoretical step was taken by the French chemist Michel Eugène Chevreul who, like Goethe, is better known in other fields, such as being the inventor of margarine and one of the pioneers of gerontology. However, in 1839, when he was director of the Manifacture des Gobelins, a historic Parisian tapestry weaving workshop, he published his studies on light and colour in which he expounded the principle of "simultaneous contrast". Chevreul had noticed the increase in brightness when two complementary colours are placed side by side. In order to visualise the relationships between the colours he then drew a colour circle, which later became famous and was named after him, divided into seventy-two parts and depicting the three primary colours, red, yellow and blue, the three secondary mixtures of orange, green and violet, as well as six further secondary blends. The resulting sectors were each divided into five zones and the rays separated into twenty segments to include the various levels of brightness. The complementary colours were at the tip of each diameter.

This was an important moment. For the first time, a chromatic instrument took into account the active role our brain plays in the formation of colours. In the field of art, Chevreul's studies soon spread among the Impressionists and left a deep mark on artists such as Eugène Delacroix, Edgar Degas, Paul Signac, and especially Georges Seurat, who founded the technique of Pointillism on the basis of this research.

19th century painters, thanks to chemistry, had new colours and tones at their disposal, characterised by a hitherto unknown purity and intensity. The new pigments also cost a lot less and could be applied unsparingly, with heavy, layered brushstrokes. They did not even have to be prepared in the workshop, but were ready-made and packaged in handy tubes. Finally it was possible to paint in the open air and in any location inspired by the moment. It was a unique period in which the creativity of artists and that of chemists fed off each other, generating art movements and scientific discoveries. From this moment on, colours will also be the brightest and most varied witnesses of an epochal transition, the decline of the aristocracy and the rise of the bourgeoisie, the birth of the modern world.

THE NEW STYLE OF
THE BOURGEOISIE

After the Napoleonic era ended with the Congress of Vienna in 1815, the bourgeois class began to develop its own culture by measuring itself against the great transformations taking place in the areas of production, economics, social reform, science, and technology. The first artistic and ornamental movement to appear was the Biedermeier. Very much in vogue in Austria and Germany, at

least until 1848, it is considered the first reaction to the Napoleonic Empire Style. Some call it Romantic, others call it the "Restoration style", precisely because it tended to emphasise sobriety, stripping away all the ornamentation and excesses of the stylistic elements of the previous period. In reality it represented a transitional period in which the unbridled luxury of the nobility began to come to terms with the aspirations of the emerging bourgeoisie that gradually replaced the refined aesthetic vision of the aristocracy. From this transition, which from a chromatic point of view took on strong and sometimes sombre tones, artistic styles flourished in various fields, from music to literature to the visual arts. However, it was the alienating coldness of industrial production, with its relentless rhythms and seriality of results, that inspired the "rebellious" thinking of the Arts and Crafts movement that spread like a huge wave from England to the rest of Europe. Among its inspirers was John Ruskin — a London writer, painter and art critic — whose philosophical thinking was based on the idea that humanity and its art should be deeply rooted in nature and ethics. In particular, his vision of art and architecture, as displayed in his magnificent paintings and drawings, made a decisive mark on the aesthetics of the Victorian and Edwardian period. Among the founders of the movement, a crucial role was played by the artist and writer William Morris, who is considered to be a precursor of modern design, influencing architecture for many years to come. The simple and artisanal medieval style inspired him to develop a new creative process and to found a design studio even though he was not an architect. This gave rise to a style that regarded craftsmanship as an expression of the value of human labour and its needs, characterised by sober and elegant colours. The colours of materials such as iron, wood and leather were combined with delicate tones having a predominance of green and beige.

Great impetus in the formation of the new bourgeois culture came from the Universal Exhibitions, spectacular fairs which expressed the Western world's modernity and faith in progress, and helped people to learn about distant lands and exotic cultures. Particularly in the mid-19th century, Europe discovered Japan, which had finally emerged from centuries of cultural and political isolation. At the London World's Fair in 1862, Europeans came into contact for the first time not only with the *ukiyo-e* prints already imported by Dutch and German merchants, but also with a large quantity of everyday products, such as porcelain, kimonos and other garments, lacquers and fans, all coming from the land of the rising sun. The impact of these creations was enormous on the taste of the newly-born bourgeois class, and the works of great artists such as Hokusai, Hiroshige and Utamaro also had a major influence on the work of their European colleagues, from Vincent Van Gogh to Pierre-Auguste Renoir, from Édouard Manet to Gustav Klimt. Generally speaking, the purity of the pictorial motifs, the linearity of the aesthetics, the elegance of the geometries, the particular choice of colours, as well as the quality of the craftsmanship, exerted an influence that reached its peak around 1870 with so-called Japonism, but which has never waned and still manages to infiltrate Western artistic expression and design today.

The approach of the new century and the advent of a new era today link them to a seemingly banal and ordinary event, the opening of a new Parisian shop in 1895. It was called "Art Nouveau Bing" and gave its name to a disruptive artistic movement that affected all decorative arts and architecture at the turn of the 20th century. It was the first global movement, the first for which the term International Style could be used. From France it quickly spread to England, across the continent and as far as the United States, taking the name Liberty in Italy, Jugendstil in Germany, Sezes-

sionstil in Austria and, in general, Modernism. It imposed itself so rapidly because the general climate was one of cultural renewal driven by the burgeoning industrial revolution and the economic and social strengthening of the bourgeoisie. In addition to the large exhibitions, there were magazines, shows and conferences to encourage the circulation of new ideas, technical innovations and new artistic expressions. This laid the foundation for the formation of a taste and style that transcended national borders and became common to a social group internationally. Modernism was a stylistic matrix that established itself in every field and was born as a reaction to 19th century academicism and eclecticism, rejected the styles of the past, and was directly inspired by nature. With the aim of pursuing a new quality as an alternative to the commercial vulgarity of machine-made industrial production, Art Nouveau preached unity of design and a formal continuity between architecture, decoration, and furniture. Its palette was based on an original interpretation of natural colours that, thanks to advances in chemistry, became reproducible even in the brightest ranges. The materials of reference were glass and wrought iron to give shape to striking "architecture-sculptures".

THE REVOLUTIONS OF THE 20TH CENTURY

With the advent of the 20th century, many things changed. The period before the First World War marked the definitive end of the merging of styles and also of the controversies between the proponents of industry and the defenders of manual skills. The development of mechanics broadened humanity's possibilities and functionality became the keyword for all everyday objects, also

thanks to the discovery and diffusion of new materials, especially plastic, which was used in every field, from fashion to furniture, to the automotive industry, giving shape to every novelty of the moment, from the radio to the telephone. As a consequence of the expressive power of the new materials, decorations considered superfluous disappeared to make room for the "naked" form. Architecture and furniture thus ceased to be a simple expression of manual labour and ended up acquiring an industrial and serial dimension.

Nature gave way to technology and the first movement to take up the challenge was that of the Italian Futurists. In 1909, the poet Tommaso Marinetti published "The Futurist Manifesto" in which he announced the birth of a cultural avant-garde that celebrated unconditional faith in progress and its revolutionary inventions. It marked a clean break with the past and affected every form of artistic expression: from literature to painting, from sculpture to poetry, to architecture, film, photography, music, and dance. At the heart of Futurist thought was the exaltation of the modern age. But there was also the drive towards patriotism and militarism, towards boldness and impetuosity, which on the eve of the First World War made sense, but later marked the condemnation of a movement considered too close to Benito Mussolini's fascist ideology. However, the Futurists were first and foremost extraordinary artists, like Umberto Boccioni, Giacomo Balla, Gino Severini, Fortunato Depero and Carlo Carrà, and architects who became mythologised like the young Antonio Sant'Elia. Their subjects were symbols of a society that was changing fast: cars, industry, aeroplanes, agitated crowds. To convey the idea of dynamism, they deformed images so they appeared to be in motion. They were helped by warm, strong colours, such as yellow, orange and red, contrasting with the grey and blue of mirrored metal.

In the meantime, the First World War contributed decisively to the development of technology, but tragically absorbed all its energies. When it was over, new waves were sweeping across Europe. In Holland, the De Stijl (The Style) movement, also known as Neoplasticism, published its manifesto, written in 1917 by Piet Mondrian and Theo van Doesburg, who defined their art form as 'abstract, essential, geometric', excluding figurative representation and curved lines as decorative superstructures. In this geometric abstractionism, everything had an elementary origin from line and plane. The colours were the primary ones: red, yellow and blue backgrounds separated by white or black lines forming right angles. The movement extended to design and architecture and found its "object" of reference in the *Rood-blauwe stoel*, the red and blue chair designed by architect Gerrit Rietveld, where colour appeared as matter, a sort of three-dimensional transposition of Mondrian's theories, capable of fixing itself in the collective imagination just like the Dutch artist's canvases.

In 1919 it was the turn of the Germans. In the socialist Weimar Republic, the Bauhaus, or rather Das Staatliches Bauhaus, the State Construction House, was founded. It was not just a school. It represented the most elaborate didactic experience of the functionalist and rationalist project that was beginning to take shape in Europe at that time. For those few years — it was closed by the Nazis in 1933 after moving from Berlin to Dessau — it was a meeting place and a reference point for all the innovative energies that swept through Europe, with important design and professional impacts on many disciplines and for many decades to come. Led first by Walter Gropius and later by Ludwig Mies van der Rohe, it brought together personalities such as Paul Klee, Wassily Kandinsky, Joseph Albers, Marcel Breuer, Johannes Itten, Theo Van Doesburg, and Bruno Taut. The school was also based on the

idea of an intellectual, scientific and design community, regardless of national, social, cultural, or even gender background; for the first time, women played a significant role in both teaching and design. They were very different people practising different disciplines, but all united in the belief that industry had the extraordinary capacity to ensure progress. At the Bauhaus, a new design method based on the renunciation of the legacy of the past and standardisation was theorised and practised. Here, Mies van der Rohe elaborated his motto *Less is more* invoking essentiality as the fundamental basis of design and ending up by encouraging the elimination of all decoration and superfluous elements in the name of an achromatic style capable of enhancing architecture, and exalting only simple, clean lines through the use of chiaroscuro. Yet Itten, Klee and Albers also worked here, and together they made a fundamental contribution to laying the foundations of the approach to colour as a functional element, while keeping its aesthetic and philosophical value alive. In particular, Itten highlighted how the optical, electromagnetic and chemical processes that occur in the human eye and brain at the sight of colours generate psychological reactions. He demonstrated how coloured light could change the appearance of objects and described the effects of colours in space, making a fundamental contribution to the development of new colour theories.

France, in those same years, ventured into very different territory, but equally left its mark on the history of art, architecture, and custom. The post-war turning point came in 1925 in Paris with the "Exposition internationale des arts décoratifs et industriels modernes" (International Exhibition of Modern Decorative and Industrial Arts). In that very title was the key to a new and different cultural era that marked the period between the two world wars in Europe and America: Art Deco. It was not a style or even

a movement, it was more a phenomenon of taste that affected the decorative arts, the visual arts, architecture, and even fashion. With Art Deco we could say that the colour of elegance was born. Soft and bright tints contrasted with the black and white of the fledgling film industry and emphasised the geometric and organic approach of a new way of creating and designing.

But the joy was short-lived. The winds of war were sweeping through a Europe already sorely tested by Fascism and Nazism, and the conflict that was unleashed ended up involving sixty-one countries worldwide and causing fifty-four million deaths.

FROM POST-WAR EUPHORIA TO TURN-OF-THE-CENTURY MINIMALISM

Paradoxically, the end of the Second World War also marked the end of the long economic crisis that had affected and devastated all Western economies during the 1930s. Indeed, it was the arms race that boosted industrial production and the economy of many countries, starting with that of the United States. The Allies, the victors of the war, made every effort to stimulate global economic recovery, effectively initiating the most incredible period of economic growth humanity has ever known, which would end only in the early 1970s with the oil crisis. From the 1950s onwards, mass consumption, which until a few years earlier had been the almost exclusive benefit of the United States, spread to many western countries, Japan and to some extent even the states of the Soviet Bloc. Economic prosperity spread and with it a new great vitality. The years of reconstruction in Europe were ones of curved lines, of cars with curved shapes, of the delicate colours of women's

fashion, symbols of growing optimism, of the desire to forget the past and to invent a new world. Pastel colours, which broaden the perception of size, and soft shapes, which erase edges and roughness, characterised the new post-war spirit. But it was with the boom of the 1960s that the market discovered young people and reformulated its aesthetic canons. Finally, colour and bright tones were used extensively, even to create polychromatic and sometimes overloaded environments. The Mexican architect Luis Barragán, who interpreted the strong colours of his own popular tradition, imposed his style made up of essential shapes and 'psychedelic' colours like cyclamen pink, indigo, periwinkle and violet all over the world. Thanks to the development of chemistry, design went wild with plastics, creating colourful and brilliant objects. For example the "Panton chair", the first chair made entirely of one piece of plastic, designed by Verner Panton in 1960 and produced by Vitra from 1967. Colour contrasts became part of the design game for every creative person, and the Optical Art movement, all about the geometric opposition of black and white, influenced many fashion and design collections by the end of the decade.

The craving for colour did not abate even with the oil crisis of the 1970s and the austerity measures that followed. On the contrary, the dominant palette of warm colours seemed to compensate for the rigidity of the times. But it was in the 1980s that colour went wild. The renewed confidence in the markets and the growing economy generated great enthusiasm. Throughout the West the society of the image took hold: appearing became more important than being. A strongly contrasting post-modernism of bright tones and phosphorescent colours made its way into architecture and design. In Italy, between 1981 and 1987, two multifaceted personalities laid down the law: Ettore Sottsass and Alessandro Mendini, the founders of Memphis and Alchimia, respectively,

two creative groups active in architecture and design, amazed the world with exaggerated and colourful fittings, furniture and objects, a strange encounter between the palettes of the Bauhaus, the irreverence of the artistic avant-garde, the shapes of toys, and the infinite possibilities of new plastic materials.

Then, all of a sudden, came the achromatic revolution. In the 1990s, design, fashion, and furniture suddenly seemed to lose interest in colour. Black, white and grey dominated, while a new minimalism began to assert itself, offering completely white environments with the aim of expanding the field of vision. Conversely, in fashion the totalising use of black, which actually narrows the field of vision, reflected the predominant canons of beauty, slender to the point of excess. In design, especially in the automotive field, shades of metallic grey prevailed. Onto this trend, at the end of the decade, a new ecological sensibility was finally grafted which advocated the use of natural materials and recycling techniques. The chromatic result was a palette of neutral, unsaturated tones. A hymn to shades of beige, pink and grey that has accompanied us for almost thirty years and from which we are only now liberating ourselves, driven by new technological possibilities and the digital revolution.

The great history of love and knowledge between Italy and colours has ancient roots. It dates back to when the Italian peninsula was the centre of the known world, the meeting point of cultures and the crossroads of trade, including pigments and dyes. Complex colour design was already in use in Roman times to decorate, or even to heat up or cool down environments. But it is with the Renaissance and the discovery of perspective that the relationship between light and colour becomes fundamental, assuring Italian art international and everlasting fame. Italy's colourful splendour, however, also derives from the richness of its landscape and natural treasures, as well as from the craftsmanship of skilled artisans who have always created extraordinary artefacts.

TITIAN'S RED, ARMANI'S GREIGE, SIENA'S EARTH

THE ITALIAN TRADITION OF COLOUR AND THE EXPRESSIVE POWER OF THE WORLD'S MOST DESIRED PALETTE

Plot twist. Pompeian red was originally yellow ochre. The most famous and beloved red of all time is said to be the unexpected result of the eruption of Vesuvius that destroyed the cities of Pompeii and Herculaneum in 79 AD. The secret was unlocked by a CNR study published in 2011, sponsored by the Superintendency of Naples and carried out by the National Institute of Optics. The colour intensity of the houses in the cities of Pompeii and Herculaneum was actually the result of an alteration because the red we see today was created by the action of the high-temperature gases emitted by Vesuvius before the outflow of lava. The eruption lasted about fifteen minutes in all and was fatal for the population who died of asphyxiation from inhaling the gases and were then submerged in lava and ash. The same thing actually happened to the walls of the houses. In ancient times, red could also be obtained by heating yellow ochre — a technique known to the ancient Romans and described by Pliny and Vitruvius — and this is precisely what the gases of Vesuvius would have done. It can also be seen with the naked eye in the cracks that furrow the red walls of Herculaneum and Pompeii. In fact experts had long known about this colour mutation, but what they did not know was the true extent of the phenomenon. Recent investigations using a spectrophotocolorimeter have made it possible to "measure" colour, while X-fluorescence can reveal the presence of chemical elements in order to exclude minium and cinnabar (the other two ancient methods of obtaining red and yellow). The data provided are accurate, at least for Herculaneum: today we see 246 red walls and fifty-seven yellow walls, but originally there must have been 165 and 138, respectively. So we can breathe a sigh of relief. Pompeian red has existed since antiquity. But we can also put things into perspective: Pompeii was by no means

that place of widespread licentiousness and perdition that has become fixed in our imagination because of all that red.

Talking about Pompeii helps us to tell a great story of love and knowledge, that between Italy and colour. Geographical position and an extraordinarily fertile land have made the Italian peninsula the centre of the Mediterranean, the crossroads of trade and a natural meeting point of cultures that has also generated an incomparable colour heritage sedimented over millennia of history. A polychromy that has its roots in the ancient civilisations of the Mediterranean peoples permeated by a profound consideration of colour.

THE SENSIBILITY OF THE ANCIENT ROMANS

We still associate Greco-Roman art and architecture with the simplicity of white. But this is clearly a mistake. It is a belief that took hold with Neoclassicism, starting in the second half of the 18th century. Greek and Roman ruins, worn away by the passage of time, with their whiteness and chiaroscuro inspired a new idea of perfection to contrast with the exaggerated richness of the late Baroque and Rococo periods. Only later was the original polychromy discovered. In the art and architecture of the Greeks and Romans, however, colour was not mere decoration. And indeed, the chromatic sense and knowledge of the time already allowed for a complex design of colour which, for example, in frescoes and mosaics also had the function of heating or cooling rooms. Among the examples of the masterful use of light and colour, the most striking is the Pantheon in Rome. This temple was built in 27 BC by Marcus Vipsanius Agrippa, son-in-law of Emperor Augustus.

He dedicated it to the seven planetary gods and that is why we know it as the Pantheon, which means "of all the gods" in Greek. The original building was destroyed by fire and rebuilt by Emperor Hadrian between 118 and 125 AD in the form in which we see it today. The largest dome in antiquity — forty-three metres and forty-four centimetres in diameter, surpassed only in 1436 by Filippo Brunelleschi's dome of Santa Maria del Fiore in Florence — is surmounted by the oculus, an uncovered circle nine metres in diameter through which light and heat penetrate and which is the only window in the temple. The polychromy of the building is only visible when the sun passes across the oculus and illuminates the antique yellow, the granite, porphyry, and pavonazzetto of the floor, and the concrete of the dome. But these are not just fancy special effects. In fact, the Pantheon is a solar temple that marks astronomical movements throughout the year, but which, thanks to precise architectural calculations, preserves some magic just for us. At midday of the summer solstice the sunlight entering through the great eye of the dome projects a huge luminous disc onto the floor which is exactly nine metres in diameter. At twelve noon on 21 April, the celebration of the Birth of Rome, the beam of light illuminates the northern entrance with absolute precision.

RENAISSANCE THEORIES AND TECHNIQUES

Despite the wonders of ancient Rome, the period of Italian chromatic splendour remains the Renaissance, when artists were able to rely on an extraordinary variety of raw materials from all parts of the known world from which to obtain pigments, often with exclusive formulas, to be then applied using personal painting tech-

niques. It was at this time that the relationship between light and colour became crucial thanks to perspective, which became a codified method of representation during the Renaissance. Already in medieval art various degrees of brightness were used to indicate the position of a body or surface in space: the further away it was, the darker it became. With aerial perspective, this principle was reversed and people began to observe reality more carefully: colours in depth became lighter and tones brighter, just like natural atmospheric effects. In Florence, the beating heart of the new era that attracted artists from all over the peninsula, around the middle of the 15th century, what critics have recently termed "light painting" established itself, an art form linked to the figure of Domenico Veneziano, but also employed by artists such as Andrea del Castagno, Beato Angelico, Paolo Uccello, and Piero della Francesca. In their works perspective rigour was combined with the study of light paths, colour tones were lightened and figures, including human figures, were inserted into geometric compositions to form volumes.

It was the Renaissance architect and theorist Leon Battista Alberti in his treatise on painting (*De Pictura*, 1435) who explained that colour was not a characteristic inherent to the subject of the work, but depended instead on the amount of light that hit it. He also set the canons of the new painting, starting with the four main colours, which according to Alberti were red, sky-blue, green, and ash, and from which all other necessary tones could be obtained. It was precisely ash grey that was used as a transition tone between one colour and another until the mid-15th century. Then came Leonardo who instead chose brown tones for this very purpose and created a distinctive feature of his painting, Leonardo's sfumato, which set the standard from the outset. The genius da Vinci pioneered a new way of treating drawing,

abandoning decisive strokes and obvious contours in favour of a lighter, less defined painting technique in which figures seemed to appear out of nowhere, blurred into their surroundings by evanescent outlines.

The Renaissance dispute between those who gave more importance to drawing and those who advocated colouring was resolved rather quickly and in favour of the latter. Among the masters of this new pictorial art, Sandro Botticelli combined colours by opposition. By creating contrasts of complementarity and polarity, he was able to enhance the vitality and beauty of female figures. In particular, he made exclusive use of yellow pigment in its warmest and brightest range to depict hair. Sometimes, to give greater shine, he would embellish his hair with thin lines of gold paint. The Venetian Andrea Mantegna, active at the courts of the Estensi and the Gonzagas, also indulged in refined exercises in colour. Anticipating science by many centuries, in order to depict the darkness that descends on deicidal humanity, Mantegna depicted the *Dead Christ* with the colours of scotopic vision, that is, vision mediated by rod cells, the nocturnal photoreceptors of the human eye which, despite being very sensitive, have a low chromaticity.

TITIAN AND FREEDOM OF EXPRESSION

If the vibrant polychromes of Raphael's *School of Athens* and Michelangelo's Sistine Chapel in the Vatican Museums represent the pinnacle of an incomparable chromatic tradition, it is the Renaissance Venetian school that introduced freedom to colour and applied it onto canvases or panels without the support of a meticulous preparatory drawing. The Venetians shaped light and colour

directly with brushstrokes, greatly limiting the use of pencil or charcoal. The apotheosis of this school was the 16th century when artists such as Giorgione, Titian, Veronese, and Tintoretto were active. Titian, in particular, had his own technique of applying colour at high speed. He used large format media to create large expanses of colour. Once a first layer of dense colour mass had dried, he applied more fluid, more transparent, and brighter colours. Finally he proceeded to retouch it by lightening the brighter tones and darkening the shadows using almost dry brushstrokes. He used oil colours, which were brighter and more easily diluted, to achieve different textures. For us today, he remains the master of red, a shade that still bears his name but that is actually indefinable because it is not just a single one. As Alvise Zorzi, a Venetian journalist and writer, explained on the occasion of the exhibition "From fire to light, the colours of the sacred" (2007), there are at least three Titian reds. The first is a particularly warm, rich and exquisite variety with which he painted the robes of the characters he portrayed or the models chosen to impersonate saints and gods. The second is the coppery blonde hair of the Venetian beauties he depicted to the delight of his patrons. But the third, the one that fascinated him the most, was the glow of fire, the bright, menacing red that emanates from flames, but also from burning torches, bonfires, and embers.

In the Italian tradition, even black became a reference range in the palettes of the great painters and became fixed in imagination and usage for many centuries to come. Leonardo's black, as we have seen, encompassed all the variations of shadow declined with chiaroscuro delicacy that he explained in this way: "Black and white in painting are the main ones, as long as painting is composed of shadow and light, that is, of light and dark." But a century later it was Caravaggio who overturned all the canons

of the time by giving a divine aura to light by using a sequence of simultaneous contrasts. The artist who gave painting a human dimension was also able to use artificial light to create effects that today we would call theatrical. The technique of chiaroscuro, already known and practised for some time, experienced a quantum leap with Caravaggio and entered the world of special effects with the mastery of a great photographer, two centuries before photography had been invented.

THE TREASURES OF THE LANDSCAPE AND THE CRAFTSMANSHIP OF ARTISANS

Yet Italy's great advantage in terms of colour, supremacy dare we say, is not just an artistic question. It derives from the richness of the landscapes and natural treasures of the Italian peninsula. And it derives from the craftsmanship widespread throughout its territories, throughout the workshops where skilled artisans have always transformed precious materials into sumptuous furniture, elegant clothes, and wonderful jewellery. But before the skill of any artist, Italy is defined by the green marble of Venice, the red marble of Verona, and the purple and white marble of Carrara. By terracotta with all its nuances. By the earth of Siena. By the black of ebony, a precious wood imported from distant lands, but from which the art of cabinet-making originates; it is also used in violin-making, along with the spruce of the Trentino forests, the "sonorous" fir of Paneveggio, made famous by Stradivari.

This Italy, the starting point of the great travellers of antiquity who shattered the confines of the known world, became in turn an essential destination for travellers in search of the sublime from

the 17th century onwards. The Italian peninsula is in fact inextricably linked to the Grand Tour, an essential journey for the education of young people from wealthy families, first indulged by the British aristocracy, but which in later centuries also included visitors from other European countries. Destinations included the cities of art, Rome above all, because of its archaeological ruins and art collections, and Venice, Florence, and Naples where Pompeii and Herculaneum had recently been unearthed. Italian artists, such as Giovanni Battista Piranesi and Canaletto, also took part in the Grand Tour by acting as guides to the young scions, introducing them to the wonders of their country's history and culture, or as intermediaries for purchases, or to paint views and portraits that helped spread interest and love for Italian beauty throughout Europe.

In short, the idea of "made in Italy" as a hallmark for quality, beauty and innovation is not a contemporary invention. It had already existed for a few centuries and was the basis for fruitful artistic collaborations. Take, for example, the Fornace Orsoni in Venice, the last live-fire furnace remaining in the city today, which has been producing thousands of shades of mosaics for art, design, and architecture in gold and Venetian enamel since 1888. In 1889, Angelo Orsoni, the founder, at the Universal Exhibition in Paris showcased a multicoloured panel, originally a sampler of enamels and golds, but beautiful enough to be a work of art in its own right, and demonstrated that, alongside the most daring achievements of contemporary technique, mosaic, a noble and very ancient material, also deserved a special place. The interest was enormous and years later that same panel inspired Antoni Gaudí, who chose Orsoni glass enamels to decorate the Sagrada Familia.

THE EXCELLENCE OF
ITALIAN STYLE

Today, in the applied arts, Italian style is primarily identified with fashion, heir to an ancient elegance that is the fruit of a textile tradition rich in colour and refined details. Not much more can be said about its excellence which is recognised all over the world: from the workmanship of ancient brocades to silks in vivid, deep colours, to the polychrome palettes of Pucci and Ferragamo, and Valentino's red, Gianni Versace's yellow, Fendi's beige, and that very special shade of grey, greige, invented by Giorgio Armani. Interpreting classic aesthetic models in a contemporary key, a synthesis of art and science, tradition and technology, Italian design is recognised worldwide for its functionality and beauty. This is also true of the automotive sector which has given birth to some of the most beautiful and exclusive cars in the world. And here, too, colours play an important role. What would Ferrari be without its red and Lamborghini without its yellow? Yet the myth of these two cars arose partly due to chance, partly due to the ingenuity of their constructors, and very much due to the public's imagination. The Ferrari company's red is the result of a decision taken by the International Automobile Federation. From 1922, twenty-five years before Ferrari was born and when it was Alfa Romeos that participated in auto races, the Sporting Code required each country to adopt a particular colour so that cars and drivers could be identified while racing. Italy was allotted red with a white race number, France was given blue with a white number, Germany white with a red number, and Great Britain green with a white number. Switzerland was also given red, but with a black number on white, and the USA white with a blue stripe and a white number on a blue background.

Racing red was therefore not Enzo Ferrari's choice, but he still made it a trademark and decided to keep it even when all the other manufacturers began to design custom-built bodywork, because, as he explained: "If you give a child a piece of paper and some colours and ask them to draw a car, they will surely make it red."

Also legendary is the story of Lamborghini yellow which is identified with the Miura, the symbol of the Sant'Agata Bolognese car manufacturer,. When it appeared in 1966 it was the fastest car in the world and unleashed the creativity of the manufacturers who developed a colour chart never seen before. In keeping with the fashion, design, and art of those sensational years, the plant's colour portfolio grew to record proportions; as many as eighty-six different colours were used for the 763 Lamborghini Miuras produced up to 1973. As the manufacturers explain today, Lamborghini's basic colours have always been green and orange, as well as yellow and black, the same colours as the logo of a black shield with a golden bull. But yellow Lamborghinis always appear to be the most impressive and for this reason have become entrenched in the collective memory.

It is the power of colours, but it is also the power of the "Italian lifestyle" that has succeeded in making its colour palette the most coveted, the most universally recognised, and above all the expression of a commitment to excellence in every field.

New phenomena are changing our sense of colour. The digital age, with the constant use of smartphones, computers and mega-screens, is making us accustomed to a dynamic perception of colours. Innovative production technologies are, however, offering us the possibility of developing entirely new colours which are also capable of performing ancillary functions such as absorbing noise or pollution. Our new environmental awareness is also encouraging us to eliminate solvents and harmful substances, teaching us to appreciate more natural, less stable colours that can change over time. But the future lies in biomimesis, the ability to imitate the technologies that Mother Nature has employed and controlled since the dawn of time. A new era is dawning for colour, leaving behind dyes and pigments to embrace the technology of nanostructures.

Chapter 8

MILLIONS OF PIXELS AND SHADES

THE CONTEMPORARY EVOLUTION OF TASTE IN COLOUR WITH THE ADVENT OF NEW TECHNOLOGICAL POSSIBILITIES AND THE CULTURE OF SUSTAINABILITY

A beautiful blue butterfly is teaching us how to colour without polluting. It is called *Morpho Menealus,* belongs to the Nymphalidae family, and is widespread in Central and South America. It has a wingspan of fifteen centimetres and flies very fast, but what interests us is its colour, a very bright iridescent metallic blue. In the animal kingdom, colouration is not always derived from pigments, the special chemical compounds generated by specialised cells known as chromatophores in amphibians, fish, and reptiles, and melanocytes in mammals and birds. Colour can also result from a physical phenomenon. In this case we call it structural and it is the result of how light behaves as it interacts with the microstructures on the surfaces on which it refracts. Just as in the case of the blue butterfly whose wings have tiny ridges with criss-crossed ribs capable of reflecting certain wavelengths. This is what happens in practice: the outer transverse ribs diffract the incoming waves which scatter into the interstitial spaces, and the diffracted waves interfere with each other to create a beautiful bright blue. The intensity of the colour varies, but remains uniform over a wide range of angles because it is the height of the ridges that influences the interference.

Now we have moved beyond optical physics to the field of *photonics* which studies how to control the propagation, not of light as a whole, but of the individual particles that make it up, photons. It is a recent discipline, born together with the invention of the laser which is now experiencing a moment of extraordinary development. In practice, nanostructures are now being studied that do not absorb or reflect light, but diffract it by creating interference. A game that nature has played since the beginning of time and that we humans first glimpsed only in the mid-17th century. But it took more than three centuries before it was truly understood and reproduced.

THE DISCOVERY OF IRIDESCENT COLOURS

Humans have used *structural colours* long before they knew what caused them. The British Museum in London houses the Lycurgus Cup. This is a diatreta cup, an artefact very much in vogue around the 4th century and considered to be the pinnacle of the ancient Romans' glassmaking skills. They were objects of great luxury consisting of a glass container set in a finely worked and decorated metal cage or outer shell. That of Lycurgus has an extraordinary peculiarity: it appears green when illuminated from the front, but red when the light comes from behind. It is the only object made of this type of glass that is still intact. The effect is due to the structural colour, the gold nanoparticles dispersed within the glass that interact with light. Roman glassmakers realised that precious metals added to glass could give rise to wonderful colour effects, but were unable to reproduce them systematically. They did not understand the mechanism. Which Robert Hook did in the second half of the 17th century. The English physicist, biologist, and architect, one of the protagonists of the scientific revolution, wondered why peacock feathers changed colour depending on the angle from which they were observed. He tried dipping one in water and saw that the colour actually disappeared. He looked at it under the microscope and noticed that it was covered in tiny ridges. He became convinced that the reflection and refraction of light was the secret of the feather's colour. It was actually another English scientist, Thomas Young, who explained the principle exactly about a century later. In 1803 he described iridescence as the result of interference.

Today, we understand that structural colours are produced by the interaction of light with regular structures of a few hundred

nanometres that are able to break down incident light into several reflected waves that interfere with each other, destroying or enhancing certain wavelengths in various directions. The result is iridescent or vivid colours that are much more beautiful than those obtained by pigmentation. Because pigments work by reflecting and absorbing wavelengths of light, and absorption is precisely what can diminish the brightness of a colour.

FROM PHYSICS TO NEW TECHNOLOGIES

But how did we go from discoveries in optics and chemistry to those in photonics and microbiology? It took us many years and we needed a major boost from technology. Photography and colour printing initially, but above all cinema and colour TV changed the way we relate to the colour world, introducing us to a completely new dimension. A virtual, non-tangible world, very different from the material idea of colour that we had built up over the millennia through painting, decoration, architecture, and textile dying. A world that has grown by leaps and bounds in the digital age thanks to computers, smartphones, and high-performance screens that have taught us to question how faithful a colour is, its correspondence to reality, but also its brightness and definition. We notice immediately if something does not quite match the real thing, if an actor's complexion is too flushed or if the colour tone of a tennis court appears altered. We get annoyed if images do not have enough depth and the contours are not well-defined.

Our era offers us previously unimaginable possibilities. Technological development has profoundly influenced our culture, prompting new approaches to colour whose archetypes can no longer be

traced exclusively to nature, as they had been for centuries. We are faced with a dizzying array of artificial colour stimuli. The virtual world provides us with several million colours, although it has not yet been proven that our eye can see them all.

The contemporary colour scenario is highly dynamic, and constant technological developments are challenging many practices and certainties of the past. To begin with, we have revolutionised the relationship between material and colour. Getting the desired colour is no longer a matter of painting or dyeing. We have much more sophisticated technical possibilities. Take metals, for example, until recently they were coloured by means of opaque painting or anodising, but now new processes coming from very specific areas, such as the aerospace or automotive industries, allow original colours to be obtained that are completely detached from known ranges, such as RAL.

The colours resulting from 3D printing are also "different". They appear textural, like those of frescoes and oil paintings, because imperfections on the rough surface break up the hue into many shades. What changed the horizon in ceramics was the introduction of digital printing technology with which surfaces can be "coloured" to achieve visual and tactile effects of astonishing realism. "Fake" cement, wood, marble, and stone appear truer than the real thing. Colour and decoration have invaded every field. High-quality digital printing has also hit the textile sector, from fabrics to carpets. And in wallpapers, one of the applications with the longest history, technology has become so sophisticated that we can now add technical benefits such as sound insulation and air purification to the decors.

What is emerging is a new sense of colour, and consequently a new perception of it that is dynamic and no longer static. Abstract, pure and well-defined colours no longer seem to interest us. Our

eyes look for special effects. We seek brightness, vivacity and even instability, the possibility of seeing a tone change depending on how much and how it is affected by light. A new taste formed by continuous exposure to the images and lighting of digital devices. But another momentous change is affecting our relationship with colour. Growing sensitivity to environmental issues has opened up new sustainable horizons also in terms of colour. The need to eliminate polluting components in enamels, varnishes, paints, dyes, and also those derived from manufacturing processes is leading us towards a world that is less programmable and determinable. We use natural substances that are less stable and can change significantly depending on where they originate. The resulting colour, however controlled, can never be the same and well defined. And we are learning to appreciate the result of sustainable innovation in the form of mélange colours which are never well-defined, and never immutable.

LEARNING FROM MOTHER NATURE

Colour technology is now a vast field and the most advanced research is directed towards the development of reliable, easily applicable, multi-performance solutions that withstand even prohibitive environmental stresses and the most extreme conditions of use. We are seeing the development of anti-pollution, self-cleaning materials and compounds capable of resisting mechanical actions. Nanotechnology is producing so-called smart materials that can appear to change with light, and vary with electrical or thermal stimulation. A huge amount of possibilities resulting in a potentially infinite range of colours.

We are slowly building up a technology increasingly similar to the powers Mother Nature has possessed and used for billions of years. And now that a team of researchers from the University of Cambridge has succeeded in unravelling the genetic mechanism of structural colour production, new horizons will certainly appear. British scientists have traced the genetic programming of these particular colours to flavobacteria, microorganisms with metallic, iridescent colours. And most importantly, by modifying their DNA and altering the structure of their colonies, they were able to reveal a wide range of colours, starting with the original green, and moving on to red and blue. This is a very promising result that in the future will allow us to develop biological paints capable of reacting to external stimuli in the form of natural sensors.

And so back to our blue butterfly and the discipline that is defining our time, *biomimesis* (or biomimicry). The term comes from the ancient Greek, *bíos*, life, and *mímesis*, imitation. It is actually an interdisciplinary process, somewhere between biology and technology, which prompts us to look at nature as a source of inspiration for improving human activities and techniques. Nature becomes a model, measure and guide for developing sustainable objects, artefacts and processes. By observing the blue butterfly, researchers at a California startup specialising in structural colours, Cypris Materials, founded in collaboration with chemistry Nobel Prize winner Robert H. Grubbs, are breaking new ground in this field. They have long been designing structural colours that can be applied like paint. These are polymers, long chains of molecules, capable of reflecting all light radiation (ultraviolet, visible, and infrared) resulting in a wide range of colours without using pigments or dyes. In practice, during the drying process, the polymers contained in the paint arrange themselves into ordered nanostructures that reflect specific wavelengths, resulting in spe-

cific colours. But they do have their limitations, such as difficult application and aesthetic appearance. Above all, they are iridescent colours, not exactly suited to any environment, object, or circumstance. But by studying the butterfly *Morpho Menealus* and its blue wings, Cypris Materials rendered structural colours independent of the angle of incidence of light. By creating structural dyes with self-assembling block copolymers, it has eliminated iridescence, yet still managed to exploit the mechanism. These colours could be applied in many different sectors, from electronics to packaging and cosmetics. In short, the potential applications are huge. Many other research laboratories, public and private, are busy all over the world exploring new colour technologies. Our hope is that environmental sensitivity and a sense of humanity will prevail. Because humanising the environment has to mean designing for the well-being and dignity of individuals, with full respect for nature and its processes.

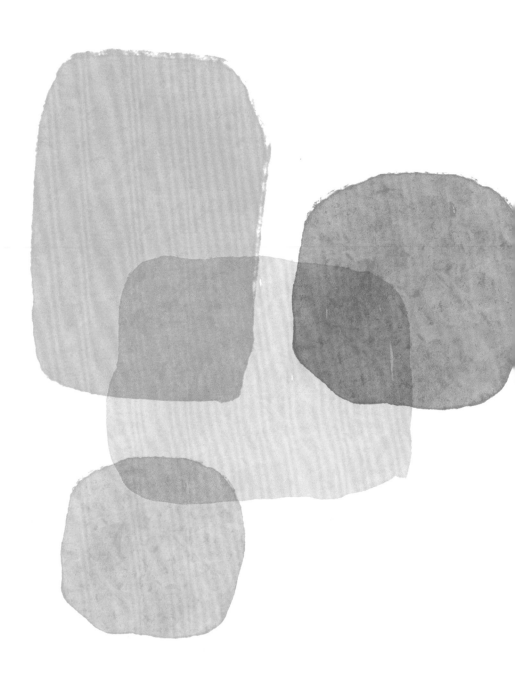

A SHORT GLOSSARY

DEFINITIONS, NAMES, EXPLANATIONS

Absorption: in physics, it is the ability of a body or material to retain and not transmit the energy of the electromagnetic radiation with which it is invested. It is a key factor in the human perception of colours.

Achromatics: these are colours without tint (chromatic tone), like black, grey, and white.

Additive synthesis: concerns the primary colours produced by light which are red, green, and blue, known by the acronym RGB (Red, Green, Blue). They are at the extremes and in the centre of the visible light spectrum and added together they create white, or rather, white light. Mixing them together in different quantities generates the entire spectrum of colours that we are able to perceive. They are also the key to the operating system of monitors, TVs, iPads, smartphones and the like, which must be created in RGB, as all these devices produce light.

Attributes of colour: the basic perceptual components of colour, or what stimulates and structures human vision. But they are also the parameters by which a colour is described. They are the chromatic tone (or hue), the saturation (or chroma), the lightness that allow each colour to be characterised by taking light into account.

Brightness: the amount of light emitted by a source or reflected from a surface that is perceived by the eye. The brightness of a colour depends on the effect light has on the retina.

Brightness: one of the three attributes of colour. But it is a generic term that belongs to common language. It is not scientific, it has nothing to do with either colorimetry or photometry. It shows the approximate amount of light coming from an illuminated coloured object by comparing it to that from a white surface. It does not have the specificity of physical quantities such as luminance, brilliance, or clarity. It is, however, an important element of visual perception. In chromatic terms, it indicates the amount of black and white present in a colour.

Chroma: see *Saturation*.

Chromatic colours: colours that have a tint. The basic colours are: red, green, yellow, blue, and their combinations.

Chromatic harmony: the in-depth correspondence between the elements and parts of a set of colours. A harmonious colour composition satisfies the eye's need for balance.

CMYK: stands for Cyan, Magenta, Yellow, and Key (black). It is a subtractive synthesis colour model used in both digital printing and traditional large press printing (gravure, offset...). Reproduction using these four inks is also called four-colour printing.

Colorimetry: a branch of spectrophotometry that deals with the absorption of visible radiation by bodies and substances. It was created to find an objective method and shared rules for measuring

colour. Since colours are nothing more than the visual perception of a band of electromagnetic radiation from the solar spectrum, a discipline was needed that could attribute precise references to colours regardless of the observer. It is of great importance for industrial production in every field as it has to define objective references to reproduce a given colour exactly and infinitely.

Colour adaptation: the ability of our visual system to adapt to changes in light to maintain the appearance of colours.

Colour circle: the representation of the colours of the visible light spectrum arranged radially within a circle. The English scientist Isaac Newton (1642-1727) also used it to represent his discoveries on light. His was a kind of pie chart whose "slices" represented one of the seven colours of the visible solar spectrum. The colours became increasingly less saturated as they moved from the circumference towards the centre of the circle, until they arrived at white, the sum of all the colours of light, as Newton himself discovered. But the colour circle as we understand it today was developed in 1861 by the French chemist Michel Eugène Chevreul to classify the colour shades of the dyes used in his textile factory. His colour circle is divided into seventy-two parts and depicts the three primary colours, red, yellow and blue, the three secondary mixtures of orange, green and violet, as well as six further secondary blends. The resulting sectors are each divided into five zones and the rays separated into twenty segments to include the various levels of brightness. Complementary colours are at the tip of each diameter. After Chevreul's, the most famous colour circle is that of Johannes Itten, a Swiss painter, designer and theorist active at the Bauhaus. His twelve-pointed star with its seven luminous gradations dates back to 1921, but

the definitive elaboration of his circle was presented in 1961 with the publication of the book *The Art of Colour*, still considered a bible for colour combinations today. It is a complex figure composed of a central triangle subdivided into the three primary colours (yellow, red, blue) surmounted by three other triangles created by the combination of the primary colours to generate the secondary ones (orange, violet, green) thereby forming a hexagon. On the outside is an outer circle made up of twelve colours (three primary, three secondary and six tertiary). Itten's circle is the one that introduces tertiary colours made up of primary colours mixed in unequal parts, situating them in the intermediate space between the vertices of the triangles of primary and secondary colours.

Colour temperature: the hue of light emitted by a light source. It is expressed in degrees Kelvin (K) on a scale of 1,000 to 12,000. The higher the Kelvin number, the whiter or bluer the light will appear. Between 2,000 and 3,000 K we find warm colours with a characteristic yellow-orange tone. Between 3,300 and 5,300 K lies so-called cold white. Above 5,300 there are shades defined as "daylight" with a bluish-white hue, similar to natural daylight that has a colour temperature of 6,500 K.

Colour tone: one of the three attributes of colour along with brightness and saturation. It is the essential quality, the one that helps us name particular colours. It corresponds to the relative wavelength of light radiation.

Complementary colours: the pairings of primary and secondary colours placed exactly opposite each other in the colour circle. A complementary pair always includes a warm and a cool colour.

This is also why the combination of complementary colours is based on strong contrasts, especially if the colours have different saturations. It is a method used by painters to make a colour appear brighter. The proximity of pure complementary colours can even generate visual changes caused by vibration. Another fundamental characteristic of these colours is that, when mixed together, they lose their hue and tend to create an intermediate greyscale colour. Another technique known to painters, who in this way can control the level of saturation of a colour that loses brilliance when mixed with its complementary.

Cones: together with rod cells they make up the two types of photoreceptors in the human eye, the nerve cells on the retina that are sensitive to light waves. They both perform the fundamental function of transforming light first into chemical and then into electrical information transmitted to the brain via the optic nerve. We have around six million cones and their specific function is to enable us to see in daylight. They are responsible for accurately capturing details and colours. There are three types, each of which contains a specific pigment that makes them sensitive to different wavelengths of the visible spectrum. Their absorption peaks are at 420, 530 and 560 nanometres, corresponding to blue, green, and red, respectively.

Contrast: this term generally refers to the juxtaposition of different elements. It can be of sound, of light, of shadows, of colours, but also of character or ideas. In an image, contrast indicates the difference between the brightest point, indicated by the highest value, and the darkest point, the lowest value. In the world of video technology, it is a key variable along with brightness. While the latter indicates the amount of light emitted, for example by

a screen, contrast refers to the ratio between the area of greatest emission and that of lowest emission. We speak of colour contrast when there is a noticeable difference between two colours when compared.

Cyan: together with yellow and magenta (red) it constitutes the three primary colours of subtractive synthesis. It has a wavelength of around 500 nanometres. It is a colour equidistant between cool and warm tones, sometimes called turquoise, or confused with various shades of blue. It is the complementary colour of red. Technically, it is defined as a subtractive primary colour and is one of the four basic colours of four-colour printing, the most widely used colour printing technique, also referred to as CMYK.

Diffraction: the deviation of the trajectory of waves when they encounter an obstacle in their path. Its effects are significant when the wavelength is comparable with the size of the obstacle. Particularly in the case of visible light (wavelength around 0.5 nanometres), diffraction phenomena occur when it interacts with objects below the millimetre scale.

Dyes: these are substances, generally organic in nature, which may be natural or synthetic, and which are soluble in solvents (such as water for example). They work by using chemical bonds to bind in a stable manner to the molecules of the substances to be coloured, such as textiles and plastics. Dyes do not simply apply a colour cover to an object, as pigments do. By creating a chemical reaction, they impart a stable colouring all over. Dyes may be of natural, animal, or plant origin, as well as artificial when prepared in the laboratory in the form of polyaromatic molecules.

Four-colour process: see *CMYK*.

Gradation: obtained by mixing one colour with varying amounts of another colour, and may be tonal or chromatic. When white or black is added to the base colour, a lighter or darker colour is obtained. Increasing the number of transitions from light to dark produces several variations of the same colour that constitute a tonal gradation. Colour gradation, on the other hand, is the result of mixing two colours, one of which is greater in quantity. The greater the number of transitions, for example from orange to yellow, the closer the gradation will be to a shade.

Interference: a physical phenomenon due to the overlapping of two or more waves at a given point in space. The most common and familiar case is that of ripples forming on a body of water. The main characteristic of interference is that the intensity of the resulting wave may be different from the sum of the intensity of each starting wave. It is known as constructive when the resulting intensity is greater and destructive if it is lower. Interference is also a typical phenomenon in the field of colour.

Magenta: together with yellow and cyan it is one of the three subtractive primary colours. It is not part of the visible radiation spectrum and so does not correspond to a specific wavelength. It is the result of mixing equal amounts of red and blue light. It is therefore a secondary colour and is complementary to green. Named after an aniline dye produced and patented in 1859 by the French chemist François-Emmanuel Verguin, it was originally called *fuchsine*, but was later renamed in honour of the battle won by French-Italian troops against the Austrians that very year at Magenta.

Mesopic vision: also called twilight vision, it occurs when the lighting level of an environment lies between day and night, and is due to the simultaneous action of cones and rods.

Nanometre: a unit of length equivalent to one billionth of a metre. It is used to indicate the wavelength of visible light which is between 380 and 780 nanometres.

Opacity: the characteristic of a body not to allow light radiation to pass through it. The surface of a material is transparent if it transmits light and an object can be observed through it; translucent if it transmits light by diffusing it but is not transparent; opaque if it is impenetrable to visible light.

Photometry: the set of techniques for measuring characteristic quantities of light, such as light energy, illuminance, luminance, luminous intensity, etc. They are important in optics because they identify the characteristics and measure the effects of light radiation on the human eye.

Photopic vision: also called diurnal vision, it is due exclusively to the activity of cones, one of the two types of photoreceptors in the retina, and occurs in the presence of daylight or equivalent lighting, enabling us to see colours.

Pigment: a substance used to change the colour of a material. It differs from dye because it does not dissolve in either common solvents (even water) or in the surface to be coloured. This is why we speak of dispersion. So pigments are coloured substances, insoluble in the medium in which they are used, whose colouring action derives from mechanical dispersion in the medium itself.

They are usually called "earths" because most traditional colours come from natural mineral deposits. Pigments can be organic or inorganic (mineral). Both can be natural or artificial. Among the best known plant pigments are chlorophylls (the green parts of plants), carotenoids (yellow-orange colours), and anthocyanins (violet colours). Mineral pigments are inorganic compounds consisting of more or less fine, coloured powders that are insoluble in the dispersing medium with which they form a more or less dense paste to be applied onto the surface to be coloured.

Polar colours: these are the opposite colours in the colour circle, but they are neither primary nor secondary but tertiary, such as red-orange opposed to green-blue.

Primary colours: these cannot be generated by mixing other colours. By mixing them in various ways, all the colours that exist in nature can be obtained. There are two different triads, depending on whether we are talking about matter or light. For matter, it is yellow, red and blue that, mixed in equal parts, generate black through subtractive synthesis (by superimposing them, light is removed). For light, red, green, and blue are defined as primary, which, when superimposed, generate white. In this case we speak of additive synthesis, because light is added in the process.

Pure colours: a colour is defined as pure if it contains no other colours, including white, grey, or black. Consequently, impure colours are those mixed with other hues. Pure colours have the highest degree of saturation.

Quality: in colour it is represented by its degree of purity.

Reflection: the physical phenomenon whereby a propagating wave changes direction due to an impact with a reflective material, that is, a material that cannot be penetrated. In acoustics, it is the cause of echoes, for example, and is the basis of sonar operation. When we talk about light, along with reflection we must also consider absorption and transmission, the phenomena that occur when light radiation interacts with matter. When light strikes a body, it is partly absorbed, partly reflected, and partly transmitted.

Refraction: the phenomenon that occurs when light passes from one medium to another having different physical and chemical properties. If a light ray travelling through a transparent medium, like air for example, encounters a new transparent medium, such as water or glass, it undergoes a deflection. This is why when we dip a stick into a glass of water it appears to bend. Every medium in which light radiation is propagated is characterised by a refractive index that depends on various factors and rises as the density of the medium increases. A vacuum is the basic parameter and has a refractive index of 1. That of air is 1.0003, water has an index of 1.33, and glass 1.4. Diamond, the most dispersive substance known in nature, has an index of over 2.4.

RGB: the acronym for Red, Green, Blue, the three primary colours produced by light that form the basis of additive synthesis.

Rod cells: one of two types of photoreceptors, the nerve cells on the retina that are sensitive to light waves. Together with cones, the other type of photoreceptor, they perform the fundamental function of transforming light first into chemical and then into electrical information transmitted to the brain via the optic nerve. We have around 120 million of them and their specific function

is to enable us to see at night. They convey an image that is not perfectly sharp, but being very sensitive to light, they allow the eye to see even under low-lighting. And we describe this as scotopic or even twilight vision.

Saturation: one of the three basic attributes of colour. It represents its degree of purity. A highly saturated tint has a vivid, striking colour. As the saturation decreases, the colour becomes softer and tends towards grey. If saturation is removed completely, the colour turns into a shade of grey. The saturation of a colour depends on the intensity of the light and the wavelength spectrum over which it is distributed. Pure colour is achieved when light is on a single wavelength, which is why the colours of the solar spectrum are the most saturated and the brightest. Saturation can be contextual or non-contextual. In the first case, it defines the purity and fullness of a colour in relation to a white surface under identical lighting. In the second case, it defines the purity and fullness of colour in relation solely to the intensity of its isolated perception. To desaturate a colour, white, black, or grey is added, or its complement can be used.

Scotopic vision: also called night vision, it is activated in the absence of light and is the perception of the human eye using only rods, one of the two types of photoreceptors in the retina. It is monochromatic, because it allows us to detect differences in brightness, but not colours. It does not have a high degree of definition and is triggered when the lighting level is low. In this situation, any light radiation generates the same colour sensation and the hues we perceive range from grey to blue or dark green.

Secondary colours: obtained by mixing two primary colours in equal parts. They are orange (yellow + red), green (yellow + blue),

and purple (red + blue) by subtractive synthesis. By additive synthesis they are cyan (blue + green), magenta (blue + red), and yellow (green + red).

Shade: see *Colour tone*.

Shading: a type of gradation. It occurs when the transition from one colour to another is so gradual that the boundary between them is almost imperceptible.

Structural colours: tints that do not derive from a pigment but from the particular arrangement of surface molecular structures interacting with light from different angles. The light phenomena that cause them are interference, diffraction, and scattering. This is why they change according to the point of view, resulting in iridescence. In nature, structural colours are found in butterfly wings, peacock feathers, or beetle shells. They represent the new frontier of colour research.

Subtractive synthesis: here we are talking about the primary colours of pigments which are the characteristics of matter. Materials selectively absorb and reflect wavelengths of light. The colour we perceive is that determined by the colours subtracted from white light. The primary colours of subtractive synthesis are cyan, magenta, and yellow. Mixing them together results in black. However, pigments are never pure enough to achieve a perfect black, so in four-colour printing techniques (CMYK), artificial black pigment (K) is added.

Tertiary colours: those described by Johannes Itten and represented in his colour circle. They concern subtractive synthesis

and there are six. They come from the union of a primary and a secondary colour, and are recognised by their compound name: red-orange, yellow-orange, yellow-green, green-blue, blue-violet, and red-violet.

Tint: see *Colour tone*.

Value: see *Brightness*.

Weight: in the field of colour it is the inverse perception of brightness and clarity. The darker the shade, the heavier it appears; the lighter it is, the more delicate and rarified it seems.

ACKNOWLEDGEMENTS

This book would not exist without the fundamental contribution of a number of people who, through their studies, writings and valuable advice, have been able to pass on their passion for colour. Thanks to Giuseppe Di Napoli, Lia Luzzatto, Edda Mally, Alberto Oliverio and Narciso Silvestrini, great colour experts and generous teachers.

A warm thank you also goes to IACC, the International Association of Colour Consultants, and in particular to Danielle Mahnke who made available to us the precious and fundamental archive of her husband Frank Mahnke. And thanks to IACC Italia, headquarters of the International Association of Colour Consultants, and its collaborators: Eugenia Aliata, Sebastiano Bacchi, Silvia Bellani, Laura Benedetti, Laura Candelperger, Roberta D'amico, Flaminia De Rossi, Lorenzo Di Palma, Monica Doniselli, Tommaso Farina, Elena Fei, Bruna Ferrazzini, Stephanie Gurk, Alexander Karnutsch, Jin Hee Lee, Nello Marelli, Marta Nuresi, Nadia Palermo, Pietro Palladino, Serena Poletto Ghella, Laura Sangiorgi and Emanuela Volpe.

But it is to Marcella Meciani, editorial director of Vallardi editore, that we owe our deep gratitude for bringing us together and proposing that we collaborate. Thanks to Corrada Picchi, member of the editorial staff at Vallardi publishers, an excellent and patient editor.

Two special people deserve credit for having unknowingly initiated the project of this book some time ago. Many thanks therefore to Wendy Wheatley, friend and expert translator who introduced Massimo to Marcella Meciani, and many thanks to Manù Bonaiti, friend and passionate colour consultant at Baolab studio, who introduced Silvia to the joy of the world of colours.

Of course, we would like to thank all the family, friends and neighbours who also had to endure the stages of writing the book during this already difficult time, but who always supported and encouraged us by patiently listening to our doubts and lengthy re-readings chapter by chapter.

Finally, the biggest thank you goes to you the readers, those who managed to get all the way to the end, and those who just leafed through it. We would like to let you know that this book was born out of the realisation that it is not possible to state everything there is to say about colour, and that is why we have chosen a special formula: a travelogue into the experience of colour that we hope has aroused your curiosity and desire to delve further into this vast and wonderful subject.

ACKNOWLEDGEMENTS

BIBLIOGRAPHICAL NOTE

We thought about it long and hard, but then decided not to include a bibliography of colour at the end of this book.

Given the scientific, technical, historical, and academic texts, practical manuals, novels and books of pure entertainment, there are so many publications on the subject and of such a varied nature that even a minimal selection would be too extensive and perhaps even misleading.

Some fundamental texts are quoted in the pages of the book, but you should not consider them compulsory reading. Instead, we invite you to follow your curiosity, to delve deeper into what you are passionate about and hope that your experience in the fantastic world of colour does not end here.